By
Stephen Rebello
and
Richard Allen

Abbeville Press · Publishers
New York · London · Paris

First edition, Tiny Folios™ format

Library of Congress Cataloging-in-Publication Data

Rebello, Stephen.
Reel art: great posters from the golden age of the silver screen by
Stephen Rebello and Richard Allen.
p. cm.
Bibliography: p.
Includes indexes.
ISBN 1-55859-403-5
1. Film posters. I. Allen, Richard, 1921– . II. Title.
PN1995.9.P5R44 1988 88-10451
791.43 — dc 19 CIP

CONTENTS

INTRODUCTION

That's the kind of advertising I like.
Just the facts. No exaggeration . . .
Samuel Goldwyn

he decades from 1910 through 1950 witnessed the ascendance and triumph of the big studio movie-making system, as well as the beginning of its end. During these years, Hollywood's myth-making machinery rumbled merrily, and America went movie mad. The engine of the machine was the studios' advertising art and publicity departments. Stars vamped us from luminescent portrait photographs, fan magazine covers and ads, sheet music, Dixie Cup lids, glassware, cigarette and penny arcade cards. Heavily laundered (often totally fabricated) magazine and newspaper articles told us what they read, how the Gables and Crawfords dined, partied, loved, suffered for their art, and lavished away their millions. Even their costumes—or knock-offs thereof—were available to the plebes off the racks at local emporia. America swallowed Hollywood whole: paper dolls, movie-book tie-ins, prefab radio and newspaper interviews, personal-appearance tours.

Of all the promotional gizmos of the biz, only movie posters romanced ticket buyers where it most counted: at the point of sale. Between 1925 and 1950, when average weekly movie attendance soared to 95,000,000 and weekly box-office receipts peaked at close to two

billion dollars—even with seventy-five-cent tickets—movie posters bombarded the eye from every available vantage point: brilliantly lighted theater lobbies, billboards, brick walls, roofs, fences, buses, even taxicab wheel covers.

During decades in which the average number of movies released weekly climbed as high as seventeen and never slumped lower than ten, films arrived and vanished in a matter of days. The survival of a movie distributor or theater owner depended on the public's knowing about their product *fast*. Compared to other commercial commodities such as laundry detergent or toothpaste, the shelf life of a film was fleeting. For every picture released, the mightiest of major studios to scrappiest independent distributor mapped out national "campaign" strategies packaged in manuals called "pressbooks" or "showman's manuals." Aimed at luring "target" audiences in every "territory," these campaigns came replete with sales "tools," including such "accessories" as a full line of various-sized movie posters.

Movie campaigns came as elaborate or as meager as imagination and advertising budget allowed. The job of the poster was to capture a film's essence at a glance or, more precisely, to magnify that essence beyond all reason. From the teens through the forties, movies competed for the same spare change as a variety of other entertainment forms— fairs, circuses, stage shows, vaudeville, radio, and, from 1950 on, television. Posters needed to be sensational.

Although both the art and hustle of American movie poster exploitation spring most directly from handbills and posters for Wild West shows, carnivals, the popular stage, and the circus, the antecedents stretch back even further. We could look—and certainly C. B. De Mille would approve—to the Greeks, Egyptians, and Romans, who painted warnings and notices on city gates, temples, and tombs. But the movie

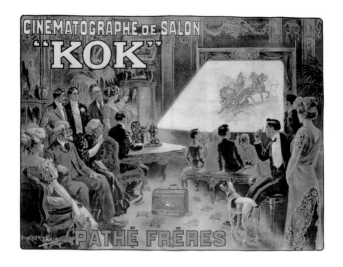

**Cinématographe de
Salon "Kok"**
France (ca. 1912)
Courtesy Poster
Auctions, Intl., Inc.,
New York

poster harks most directly back to the ebullient theatrical posters of Jules Chéret (1836–1932).

What made Chéret's work possible was lithography, which, around 1798, liberated posters from restrictive, costly methods of wood and copper engraving. An Austrian named Alois Senefelder, trying to concoct a speedy means of printing plays and sheet music, discovered the basic principle of lithography: grease and water do not mix. Senefelder's discovery allowed the artist to draw his work directly on soft limestone slabs, using a greasy chalk or ink that attracts lithographic ink. The surface of the porous stone is then washed with water, which soaks into the non-greasy areas (that is, the areas that have not been drawn upon). Lithographic ink, repelled by the wet surface, adheres only to the design area, enabling one to transfer to paper in the printing process a perfect facsimile of what had been drawn on the stone. With the advent of lithography, *the* medium for theatrical subjects had arrived.

In Paris, Jules Chéret produced in 1858 the highly theatrical *Orphée aux Enfers*, his first color lithograph. Within eight years, he was busily turning out color lithos, over a thousand designs in all, from his own studio. The artist's technical mastery of scale, contiguous flat masses, translucency, and his selection of subjects—the circus, theater, scintillating women, and la vie bohème—won him such huge popularity that, by 1896, poster collecting swept Europe.

Toulouse-Lautrec's (1864–1901) thirty-one masterful posters enjoyed far less public acclaim than did Chéret's, but they wonderfully caricatured the artist's Parisian comrades who cavorted on either side of the cabaret footlights. Alphonse Mucha (1860–1939), from whom Sarah Bernhardt commissioned a poster to sell tickets to her *Gismonda* (1894), further reinforced the identification of the lithographic poster with show business. In England, Dudley Hardy's (1867--1922) much-

admired posters for *Gaiety Girl* productions (ca. 1895) and Frederick Walker's black-and-white lithographs for *The Woman in White* (1871) again demonstrated the medium's box-office potential.

But it was Jules Chéret himself who fathered the movie poster when, around 1890, he produced a lithograph for a short film program, *Projections Artistiques*, depicting a young miss displaying a placard with show times. In 1892, Chéret also designed the splendid *Pantomimes Lumineuses* poster for Emile Reynaud's Théâtre Optique. Reynaud presented *Pantomimes* in the Musée Grévin for nine years running. Five hundred thousand spectators, cinema's first paying audiences, thrilled to moving images painted on celluloid strips run through a projector.

Auguste and Louis Lumière's short films *L'Arrivée d'un Train en gare* and *L'Arroseur Arrosé*, first shown on December 28, 1895, in the Salon Indien of the Grand Café, 14 Boulevard des Capucines, inspired the first film poster to depict actual scenes. One poster, by Henri Brispot (1848–1928), illustrated family audiences gathering at the Salon, while another, by artist M. Auzolle, depicted—in full color—a well-heeled family audience delighted by a black-and-white movie in which two men cavorted with a water hose. Artist Louis Coulet's now-famous 1902 "stock" poster for films shown in the Salle de l'Etoile depicted another genteel audience backgrounded by the projector's beam pointing toward a screenlike space on which the theater's program might be printed or handwritten.

America

American movie poster history began ten years later than it did in France when, in 1900, the American Entertainment Company circulated

a poster showing a movie audience thrilling to an onscreen brass band, an image very likely lifted from a film shot in Newark, New Jersey, by Thomas Alva Edison's budding film company. The production and distribution of such a poster indicated that lithographic companies had recognized an important new source of revenue in the movie market. Around the same time, Americans produced "stock" posters similar to European examples—showing a lovely lass holding a card on which film programs or show times were printed. Simply by pasting over a new sheet weekly, the stock poster could be recycled indefinitely. Posters for short films like Edwin S. Porter's *The Great Train Robbery* (1903) heightened public awareness of specific movie offerings.

In 1908, Edison, having already created the Kinetograph camera, the Kinetoscope viewer, and the world's first film studio, co-opted his strongest filmmaking competitors (Biograph, Essanay, Kalem, Kleine, Lubin, Selig, and Vitagraph) by forming a trust known as the Motion Picture Patents Company. In 1910, he formed the General Film Company to distribute trust members' films and the posters to tout them.

From the first, each film company within the cartel boasted its own advertising style, complete with special border-art treatment, studio logo, and—often—slogan to distinguish its product from the rest of the pack. The overall poster format, however, varied little: a title over a black-and-white scene photograph or color lithograph, sometimes accompanied by a wheezy plot summary. The posters were sold to nickelodeon owners for fifteen cents apiece.

In several respects, Edison's advertising strategy was a signal development in American movie poster history. First, it began to standardize publicity, taking it out of the hands of regional movie exhibitors. Second, the crude design of these posters—tacit admission of America's comparatively impoverished cultural and aesthetic standards—

fixed the movie poster's second-rate status for decades. Third, by featuring photographs rather than artwork, these posters not only cut costs, but catered to the literal-mindedness of the national advertising sensibility.

"The rise of the motion picture," wrote poster historian and critic Charles Matlack Price in 1913, "has opened a new field akin to that of stage and one in which the producers do not seem to be so unenterprising as the theatrical managers. In proportion to the total number of large and expensive film productions, however, the number of good motion picture posters is deplorably small." Before World War I, with talent of the caliber of Will H. Bradley (1868–1962), Frank Xavier (1877–1924), Joseph Christian Leyendecker (1874–1951), Neysa Moran McMein (1890–1949), and Maxfield Parrish (1870–1966) at the ready, movie posters were no better—and sometimes far worse—than other forms of outdoor advertising. Movie posters slavishly aped the style (or lack thereof) of their Broadway and vaudeville forebears.

It would take World War I to ignite the billboard poster's full advertising potential. Famous artists such as Howard Chandler Christy (1873–1952), Charles Dana Gibson (1867–1944), Joseph C. Leyendecker, James Montgomery Flagg (1877–1960), and John Norton contributed to Liberty Bond and other propaganda drives. In the war's wake, outdoor advertising became big business, with twenty-four-sheets hawking ephemera from the latest Broadway extravaganzas to cigarettes, cars, soaps, and clothing. Movies, the newest and biggest rage, seemed born for the billboard's hard sell. As movie audiences demanded that film programs progress beyond simple short subjects to longer, more involved stories, billboards gained prominence in advertising Hollywood's wares.

In 1917, moviegoers could choose from an average of thirteen new

releases per week. By 1926, that number had risen to fifteen and, from that time on, new movie fare seldom fell below ten a week through to the 1940s. Yet even as it became obvious that the movies were here to stay, if they were to take hold on a grand scale, advertising was needed to help the medium break out beyond the poor and immigrant audiences that early on made up its most loyal constituency.

Until the turn of the century, audiences crammed tents and peep shows to view one-reel, hand-cranked "flickers." Around 1905, speculators began earning small fortunes by installing seats and projectors in converted arcades, stores, and warehouses. In the vanguard, in 1902, was Thomas L. Tally's "Electric Theater" in Los Angeles, a haven "For Up-to-Date High-Class Motion Picture Entertainment Especially for Ladies and Children." With Tally's success, the country witnessed ex-carnies and other hustlers scrambling to grab up cheap halls—nearly ten thousand of them overnight—to turn them into "nickelodeons," so named for the price of admission. Advertised as "Moral and pleasing to Ladies," not to mention "Thoroughly sanitary" and "Fumigated hourly," these back-street theaters presented easily digested fare from which many new Americans absorbed the country's folkways.

Nickelodeon advertising consisted of lurid sidewalk and sandwich-board poster displays supplied by local film "exchanges," and made up of 8 x 10 inch and 11 x 14 inch black-and-white scenes—"stills"—and stock posters featuring portraits or generic scenes (torrid embraces, moist-eyed dogs, wild animals, and hair's breadth escapes) on which any title might be scrawled. Some theaters hired local display artists to create better or, often, worse posters and banners in place of the standard posters. Cheaply printed handbills listing the name of the film and the cast also appeared around town and in shop windows.

By 1908, movie makers and exhibitors began capitalizing on a new

audience rage—movie stars. Increasingly, poster art glorified screen personalities. Some of the earliest performers granted the poster "star treatment" were Florence Lawrence, known as the "Biograph Girl," Vitagraph's Earle Williams, Maurice Costello, and, of course, "The Girl with the Curls," Mary Pickford. Similarly, director D. W. Griffith became the first "star director" widely known to the public, as much from making certain his name was prominently featured in his film advertising as through raw cinematic talent.

From 1915 to 1920, the budding moguls of the movie business, William Fox, Carl Laemmle, Jack Warner, and Adolph Zukor, all immigrants to America, read their audiences' tastes, needs, and quirks intuitively, and grew rich first by upgrading nickelodeons into slightly better movie houses and then by massing them into large theater chains. Later, they anticipated and courted the struggle of their audience for upward mobility by raising admission prices and building ever more comfortable movie "palaces" in which to display their cinematic creations.

Highbrows might curl their collective lips, blue-noses and newspaper scribes could rumble about "taste-pandering" or the need for censorship, but movie attendance mushroomed and profits soared. Advertising and promotion department executives turned their attention to publicity that came on like gangbusters but still provided the veneer of good taste necessary to cross class barriers.

With the rise of the studio system, movie posters were almost always conceived and illustrated in New York, where money men could oversee advertising with one eye while tracking the box office with the other. From 1915 to 1920, newly consolidating film companies like Fox, Paramount, and Universal made concerted efforts to attract strong, established artists to film poster work. New York boasted the cream of

The Storm
U.S. (1916)
Studio: Paramount
Robert S. Birchard
Collection

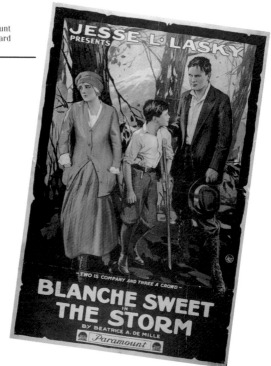

the crop of magazine and newspaper illustrators, but studio art departments were always on the alert for newer, hungrier talent. For example, to devise a poster campaign befitting "Erich von Stroheim's Wonder Play," *Blind Husbands* (1919), Universal Film Manufacturing Company held a competition that attracted seventy-five New York artists. Charles Lenox Wright's first-place winner made a spectacular centerpiece for the movie's poster campaign, and fourth-place winner A. M. Froelich was to enjoy top movie poster illustrator status for three decades. Indeed, all five of the winners won commissions from the studios.

Other studios busily recruited some of the same "name" artists whose work had become so visible during World War I. Among the day's best-paid and most prominent were M. Leone Bracker (1886–1937), Henry Clive, Harrison Fisher, and Tony Sarg (1882–1942), all of whom enjoyed steady film poster work. Bracker's shamelessly effective series of patriotic and relief-fund posters (among them, "Keep 'Em Smiling" and "Help Lest We Perish!") bolstered the war effort so mightily that he was hired for a complete poster campaign on *Man, Woman, Marriage* (1921), starring the erstwhile "kid Nazimova," Dorothy Phillips. Clive's airy, light-touch color sketches for Billy Rose's stage spectacular *Jumbo* or his rapturously idealized Broadway star portraits, Harrison Fisher's opulent, trendsetting *Cosmopolitan* cover women, Sarg's *Collier's* and *Saturday Evening Post* circus-theme cartoons—each of these won favor with Paramount Pictures studio head Adolph Zukor.

By 1923, the reputation of Zukor and publicity man Benjamin P. Schulberg (who was to become chief of production for the studio) for show business acumen had reached a high point when poster campaigns for *The Covered Wagon* and *The Ten Commandments*, both expensive epics, helped those pictures become two of film history's biggest ticket sellers. Having already made a household slogan of "If

it's a Paramount Picture, it's the best show in town." Zukor undertook in 1926 a series of national ads calculated to elevate movie-going to the realm of "the refined classes." These ads featured Thomas Edison—in an etching by Franklin Booth—proclaiming, "The movie is my principal source of theatrical entertainment." During that same year, Paramount appended this tag to their national magazine ads: "Paramount Pictures . . . Keeping the family together." Under homey family portraits, the copy read: "By daylight or moonlight, the road is open to the nearest theater. There all the members of the family may sit together under the same spell of enchantment, refreshed by the wholesome flood of make-believe, light, music and laughter that not so very long ago was part of a world so very far away."

One message was becoming increasingly clear. The days when film distributors sold theater owners celluloid by the foot had gone the way of the five-cent admission. Gone too were the days when theater exhibitors could make do with "stock" posters. Movies were growing bigger, longer, and costlier by the second, and the studio heads were out to make sure the public knew it.

THE EARLY YEARS

American Film Manufacturing

In 1910, S. S. Hutchinson, John R. Freuler, and Henry Aitken inaugurated their fledgling film company with two production units in Chicago, and another in the Southwest. By 1912, the trio was successful enough to build its own studio in Santa Barbara, California. Although by 1915 American enjoyed a high industry profile for its various product brand

names (American Star Feature, Beauty, Clipper, Flying A, Star Feature, and Mustang), the company dissolved in 1921.

Biograph

Officially the American Mutoscope and Biograph Company, this East 14th Street, New York, picture-making studio was founded in 1896 by William K. L. Dickson, Herman Casler, Harry Marvin, and Elias Koopman. Biograph not only provided an early home to D. W. Griffith, Mack Sennett, Mary Pickford, and the Gish sisters, but also exploited to the hilt a new American craze, the movie star, with its own "Biograph Girl," Florence Lawrence. In 1909, the business name was changed to Biograph Company, but more often, simply Biograph, or A. B. The company folded in 1916.

Champion

Champion Film Company, founded by Mark Dintenfass, began independent production in 1910. In 1912, the company was among several of those absorbed into a cartel of picture makers that became Universal Film Manufacturing Company, later known as Universal Pictures.

Edison

In Orange, New Jersey, 1893, Thomas Alva Edison and his staff devised the Kinetophonograph, which showed a film synchronized with a phonograph record "soundtrack." By 1893, Edison was turning out his own films at the Black Maria, the world's first movie studio. Three years later, the Edison Vitascope—a program of twelve short subjects—de-

The Broken Window
U.S. (1915)
Studio: American Film
Manufacturing Company
Robert S. Birchard
Collection

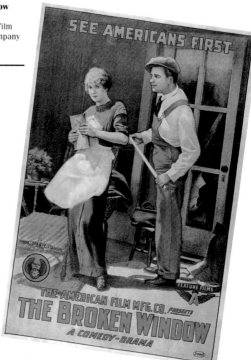

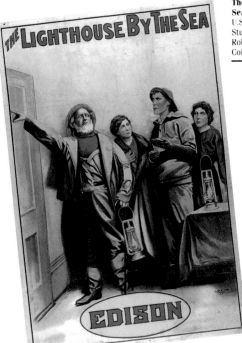

The Lighthouse by the Sea
U.S. (1915)
Studio: Edison
Robert S. Birchard
Collection

buted at the Koster and Bial Music Hall on 34th Street and Broadway, New York. Edison, attempting to snuff the dozens of independent filmmakers crowding his turf, organized the Motion Picture Patents Company in 1908. Although the inventor-entrepreneur effectively lost his business when the monopoly was dissolved in 1917, the Edison Company continued into 1918.

Kalem

Founded in 1907 and named after George Kleine, Samuel Long, and Frank Marion, this company burst into notoriety for its *Ben-Hur* one-reeler, shot during a chariot race staged for a fireworks show on Manhattan Beach in New York. Averaging two hundred releases a year—*From the Manger to the Cross* (1912) among its least typical—the company boasted its own "Kalem Girl," Gene Gauntier, who also doubled as its screenwriter.

Mutual

This company, founded in 1912 by Harry E. Aitken and associates, was comprised of many subsidiaries, among them Komic, Majestic, and Keystone. The latter's frenzied Kops and Bathing Beauties comedies by director Mack Sennett put the company on the map. Komic, an independent company whose breakneck farces made its name, was formed in 1910 by tobacco sales executive Herbert J. Yates, then nineteen, who financed several pictures starring Roscoe "Fatty" Arbuckle. Yates became president and chairman of the board of Republic Pictures. Harry Aitken founded Majestic in 1911 and began its association with Mutual the following year. In 1913, Majestic and Reliance joined forces.

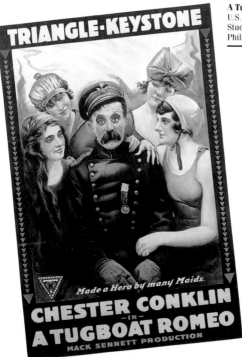

A Tugboat Romeo
U.S. (1916)
Studio: Keystone
Philip Shimkin Collection

Keystone Studios, which headquartered in Edendale, California, boasted a matchless stock company: Roscoe "Fatty" Arbuckle, Charlie Chaplin, Chester Conklin, Charley Chase, Minta Durfee, Louise Fazenda, Mabel Normand, Ford Sterling, and Fred Mace. Though a 1915 merger with Triangle led to Keystone's demise two years later, the laughter continues. Mutual, whose motto was "A Mutual Movie Makes Time Fly," was eventually bought out by Film Booking Offices of America, which later became part of RKO.

New York Motion Picture Company

In 1909, Adam Kessel, Jr., Charles O. Bauman, and Fred Balshofer began this independent production firm, making films in Coytesville, New Jersey. Shortly after, they branched out into making Westerns in Edendale, California, and later, Venice, California, where they bought out the winter headquarters of a Wild West show. From then on, the corporate profile emerged as "101 Bison." Although Kessel and Bauman were stripped of the Bison logo and identity when they annexed with Universal, the duo renewed their identification with Westerns through an association with Thomas Ince.

Ince, a down-on-his-luck actor in 1909, leapt at the chance to direct Mary Pickford in films for Carl Laemmle's Independent Motion Picture Company. Some of these movies were shot in Cuba, beyond the reach of the monopolistic Motion Picture Patents Company. In 1911, Ince moved to New York Motion Picture Company, where he directed a series of crack Westerns. Profits from this work gave Ince the means to lease 20,000 acres from the Santa Monica Land and Water Company for a studio dubbed "Inceville." Within five years, Ince had formed his own core of contract stars, including the hugely popular Western actor Wil-

liam S. Hart, and helped launch the careers of such directors as Frank Borzage, Jack Conway, and Fred Niblo.

Pathé

In 1896, in France, Charles Pathé and his three brothers founded this company on profits from exhibiting an Edison phonograph at fairs and selling cheaper home versions of the same. In 1902, Pathé built a studio and, with director Ferdinand Zecca, began churning out films at a clip of two a day. Within six years, Pathé Frères had grown into an empire, with branches in New York, London, Moscow, Budapest, and Calcutta. Moving into the manufacture of raw film stock and equipment, Pathé also invented its own color process and the world's first newsreel, "Pathé-Journal." In 1914, Pathé came to conquer America, but, by 1918, the once-mighty company was in precipitous decline.

Thanhouser

A converted skating rink in New Rochelle, New York, housed this independent production company founded by Edwin Thanhouser in 1910. Thanhouser folded the company in 1918, when it collapsed along with Mutual Pictures.

Triangle

In 1915, the founder of Mutual, Harry Aitken, pooled his resources with those of Charles O. Bauman and Adam Kessel, Jr., to form one of the most prestigious of early film companies. For three spectacular years, Triangle—named for its three top filmmakers, D. W. Griffith, Thomas

Little Dick's First Case
U.S. (1915)
Studio: Majestic
Robert S. Birchard
Collection

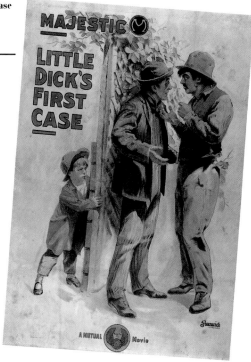

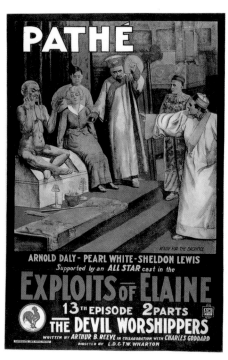

Exploits of Elaine:
The Devil Worshippers
U.S. (1915)
Studio: Pathé
Robert S. Birchard
Collection

The Flying Torpedo
U.S. (1916)
Studio: Triangle
Robert S. Birchard
Collection

Ince, and Mack Sennett—commanded the poshest film properties, the best theaters, the highest ticket prices. Griffith's gargantuan, costly *Intolerance* (1916) crippled the company and, after Griffith and Sennett defected in 1917, Triangle closed shop the following year.

Vitagraph

One of the most successful of the vanguard companies, Vitagraph entered the business in 1896 with shorts about Niagara actually filmed at New Jersey's Passaic Falls and Spanish-American War "documentaries" shot in water tanks. Still, sufficient profits rolled in for founders J. Stuart Blackton and Albert E. Smith to open a Brooklyn studio in 1906 and a California counterpart in 1911. Rudolph Valentino, Adolphe Menjou, Clara Kimball Young, and Norma Talmadge all started at this company, which the brothers Warner bought out in 1925.

INTO THE BIG TIME

By the mid 1900s, attention-grabbing film posters had become the norm for the nation's theater fronts and lobbies. Around 1920, the period during which the industry first began toning up its image if not its product, film producers and distributors began standardizing national movie campaigns. As part of that process, movie poster sizes and the frames in which to display them were also brought into line. With the growing importance of studio-owned theater chains, studio heads began to undertake national publicity with far greater planning, hiring writers and illustrators to devise sales campaigns under the direction of advertising and exploitation department heads.

One important product of this shift, which first appeared around 1917, was the "pressbook" or "showman's manual," containing the sum of a studio's wisdom on promoting a film. During the twenties, the pressbook might run anywhere from a single page to about a dozen. In the thirties and forties, when many studios employed pressbook editors and art staffs, the page count sometimes grew to nearly a hundred. Each pressbook was a primer on movie exploitation, advising theater owners on how to stage elaborately silly publicity stunts ("Guess the secrets of hobohemia and see *Beggars of Life* free!" or "Girls with 2 boyfriends—bring them to see *Design for Living* and get in free!"), ready-made newspaper ads, feature articles ("Did *you* know Tallulah's name means 'rippling water'?"), even prefab movie reviews.

A 1932 Paramount pressbook for *Love Me Tonight* suggests a contest to find actress Jeanette MacDonald "An Ideal Hubby," from among, of course, a dozen or so of her fellow Paramount contract stars. Another, from 1933, went all weak-kneed at how actress Miriam Hopkins intended to write her own screenplays (but never did), while still another from the same year, for *From Hell to Heaven*, trumpeted artist McLelland Barclay (1891–1943) picking Carole Lombard as his "Dream Girl."

Pressbooks, crammed with the gush churned out by studio staff publicity writers, also displayed the full range of posters available to the theater owners. Sometimes, if the film was deemed especially grand, such as those released by Paramount or MGM, the poster campaigns were shown in full color. Among the poster choices were the one-sheet measuring 27 x 41 inches (69 x 104 cm.), the earliest and most common format. In the late 1920s, Paramount executives claimed a print run of as many as 20,000 one-sheets for "big" pictures. Today, however, representatives of Continental and Morgan Litho recall their

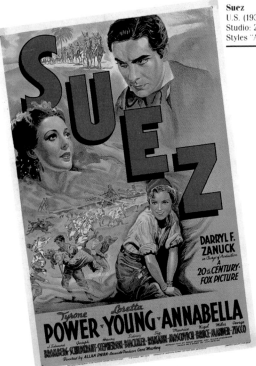

Suez
U.S. (1938)
Studio: 20th Century-Fox
Styles "A" and "B"

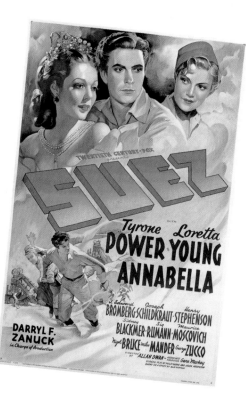

average 1930s one-sheet print run as 7,000 to 13,000.

For particularly exploitable movies, studios often worked up "advance" or "teaser" one-sheets that heralded the arrival of a film weeks or months ahead of its theater bookings. For these major releases, studios also frequently offered "regular release" one-sheets in two—and sometimes as many as four—different artwork styles, each calculated to appeal to a diverse segment of ticket buyers. As Paramount's president Adolph Zukor viewed it, "Poster art is designed to appeal to a heterogeneous class of people, a people whose cultural tastes originate in a wide variety of backgrounds." One-sheets cost theater owners about fifteen cents each during the 1930s. Depending on the studio, one-sheet poster styles were marked "Style A" or "Style B" (as was Paramount's wont), "Style C" or "Style D" (the MGM format) or even "Style X" and "Style Y" (the choice of Universal in the early thirties). These styles were annotated either on the lower white border or bottom artwork section of each poster. Whatever the demarcation, one poster format usually stressed romance or swank (ostensibly to appeal to women or urban audiences), while another took a folksier approach, favoring action over romance. Some movie advertising experts term the latter the "schmeer approach," meaning a splashy, lower-brow selling tactic. "We realize that some towns won't go for 'dressed up' pictures," acknowledged a 1933 advertising manual for the movie version of Noel Coward's ménage à trois stage hit, *Design for Living*, "so many of the ads contain illustration of the players in street clothes."

The next larger poster size, the 30 x 40, came into existence in the early thirties. Available in several formats, the most striking of which were ten-color silk screens, 30 x 40s were printed on heavier-stock paper than one-sheets and were available through New York's American Display Company, later called National Screen Accessories. Also avail-

able in this size were "photo blowups," featuring a scene or star portrait.

An even larger poster size had been around since 1912. The three-sheet, measuring 41 x 81 inches (104 x 205 cm.) exploited feverish colors and design and was meant to command the eye from a distance, as was the six-sheet, measuring 81 x 81 inches (205 x 205 cm.). Again, for particularly splashy extravaganzas, such as a De Mille picture, theater exhibitors could choose between two, and sometimes even three three-sheet and six-sheet designs. During the thirties and forties, about three to four hundred of the three- and six-sheets were printed, costing exhibitors forty-five cents each. Although some deluxe theaters displayed these sizes to powerhouse effect, they more often found their way to unused walls and fences, or were cut up by theater owners for collage-type lobby displays.

Although forty-eight-sheets were not unheard of, the largest standard-size poster was the twenty-four-sheet billboard, which—while the size was rarely standardized—was conceived as being the approximate equal of twenty-four one-sheets, but, in reality, ended up closer to 9 x 24 feet (2.7 x 7.3 m.). This size debuted around World War I and gained increasing popularity throughout the twenties and thirties. Calculated as literal traffic-stoppers, about 1,000 twenty-four-sheets were printed for special pictures and, even during the Depression, cost theater owners a cool $2.40 each. In the 1940s, Paramount also occasionally featured the more compact twelve-sheet (9 x 12 feet; 2.7 x 3 m.) for extravaganzas such as De Mille's *Samson and Delilah* (1949).

Although studio advertising art department illustrators often coordinated color schemes on different-size posters so that they would harmonize if hung together, posters were otherwise hardly devised for the long haul. Printed on inexpensive paper, they were shipped to exhibitors

in all four sizes, whether or not the theaters could use them. In that exhibitors generally received instructions encouraging them to use posters "for swell cut-out display ideas," many posters featured large head shots of the stars of the film. The same Paramount advertising pressbook for *Anything Goes* (1936) that bragged that the film's 40 x 60 and 30 x 40 posters had been "reproduced from original art by Broadway leading artists" also commented on the two different one-sheet styles: "Note that the Bing Crosby head on the one-sheet is a photographic likeness, valuable for local artwork posters. Both this cut-out and the cut-out head of Ethel Merman could make inexpensive and striking marquee hangers."

If a one-, three-, six-, twenty-four-, or forty-eight-sheet did not fit a theater exhibitor's promotional game plan, another array remained for the choosing. These included midget window cards (8 x 14 inches), at five cents a pop, often displayed in store windows, barber shops, and magazine stands; regular-size windows cards (14 x 22 inches) for seven cents; double window cards (22 x 28 inches) for ten cents (or $1.25 with frame); burgees, or banners (24 x 82½ inches), at sixty cents each; heralds at $3.50 per thousand; portrait photo enlargements (27 x 41 inches) at $2.00 each; insert cards (14 x 36 inches) at twenty-five cents; half-sheet displays (22 x 28 inches) at forty cents each; two styles of photo blow-ups (30 x 40 inches and 40 x 60 inches for $1.25); cardboard lobby standees of varying sizes at $3.75 each; 8 x 10 stills or publicity photos at ten cents each; and 11 x 14 color lobby card sets—usually comprised of seven tinted scenes from the film and one "title card" (combining art and photographs) at seventy-five cents for the set.

As Hollywood studios standardized their production methods, movie campaigns were becoming as streamlined and formulaic as the industry itself.

One

MOVERS AND SHAPERS: ART DIRECTORS AND ILLUSTRATORS ON THE JOB

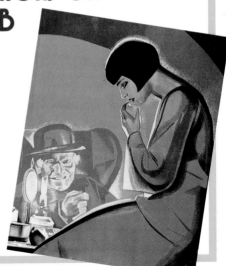

Dr. Jekyll and Mr. Hyde
U.S. (1931)
Studio: Paramount
French affiche
Todd Feiertag Collection

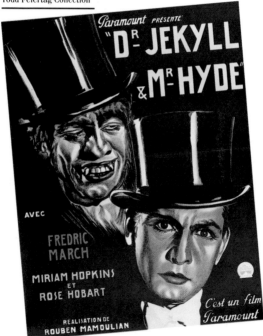

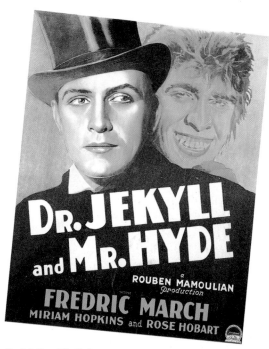

Dr. Jekyll and Mr. Hyde
U.S. (1931)
Studio: Paramount
Todd Feiertag Collection

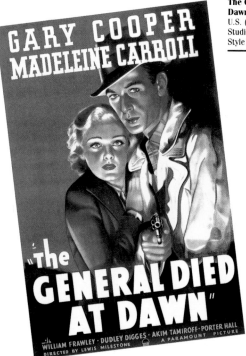

The General Died at Dawn
U.S. (1936)
Studio: Paramount
Style "A"

For Whom the Bells Toll
U.S. (1943)
Studio: Paramount
Style "A"

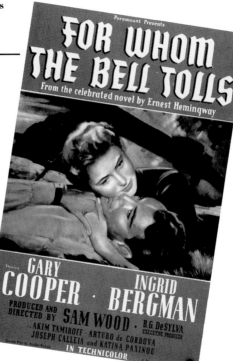

The love that lifted a man to
paradise and hurled
him back to earth again!

LESLIE
HOWARD

IN

the greatest novel of the twentieth century

"OF HUMAN
BONDAGE"

By

W. SOMERSET MAUGHAM

Author of "Rain"

DIRECTED BY JOHN CROMWELL

Of Human Bondage
U.S. (1934)
Studio: RKO

The Big Parade
U.S. (1925)
Studio: MGM
John E. Allen, Inc.,
Archives

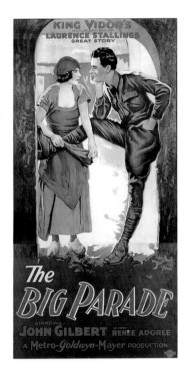

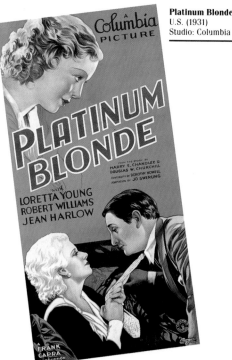

Platinum Blonde
U.S. (1931)
Studio: Columbia

Submarine
U.S. (1928)
Studio: Columbia
Robert S. Birchard
Collection

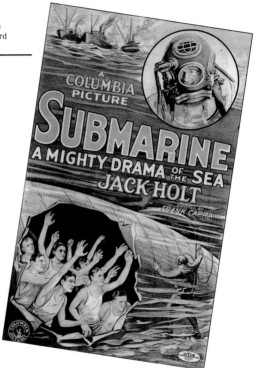

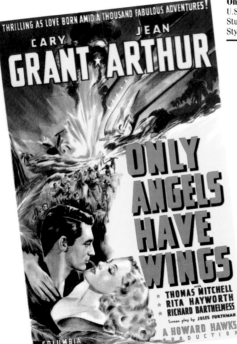

Only Angels Have Wings
U.S. (1939)
Studio: Columbia
Style "B"

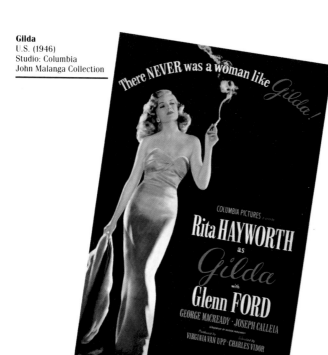

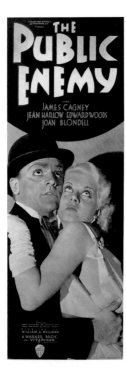

The Public Enemy
U.S. (1931)
Studio: Warner Bros.
Philip Shimkin Collection

The Razor's Edge
U.S. (1946)
Studio: 20th Century-Fox
John Malanga Collection

TYRONE
POWER
GENE
TIERNEY
JOHN
PAYNE
Anne
BAXTER
Clifton
WEBB
Herbert
MARSHALL

in

DARRYL F. ZANUCK'S
PRODUCTION OF

W. Somerset Maugham's

The
Razor's
Edge

20th
CENTURY-FOX

PRODUCED BY
DARRYL F. ZANUCK · **EDMUND GOULDING**
DIRECTED BY

SCREEN PLAY BY LAMAR TROTTI
FROM THE NOVEL BY W. SOMERSET MAUGHAM

norman rockwell

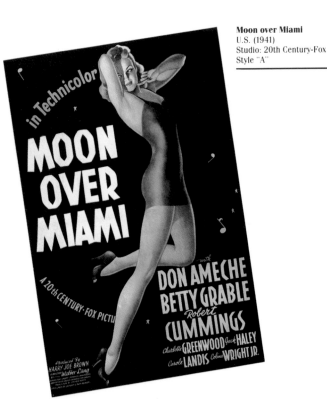

Moon over Miami
U.S. (1941)
Studio: 20th Century-Fox
Style "A"

Seventh Heaven
U.S. (1927)
Studio: Fox

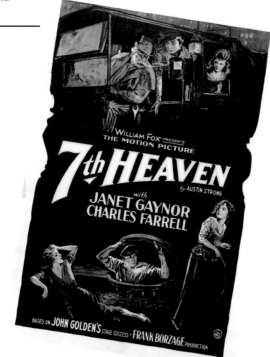

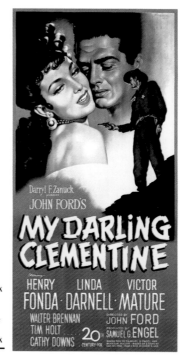

Wee Willie Winkie
U.S. (1937)
Studio: 20th Century-Fox
Style "B"

My Darling Clementine
U.S. (1946)
Studio: 20th Century-Fox

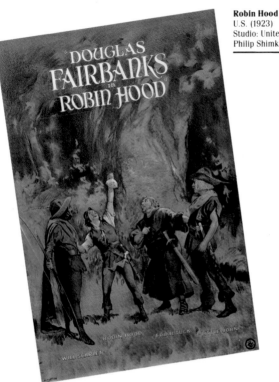

Robin Hood
U.S. (1923)
Studio: United Artists
Philip Shimkin Collection

The Hurricane
U.S. (1937)
Samuel Goldwyn
Releasing Studio: United
Artists

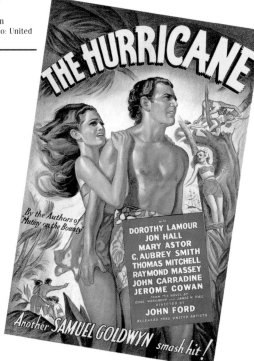

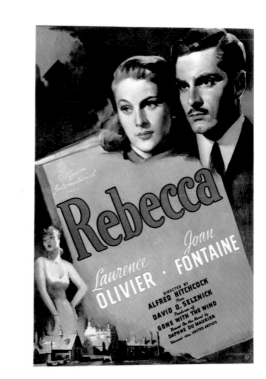

Selznick International

Rebecca

Laurence OLIVIER · Joan FONTAINE

DIRECTED BY
ALFRED HITCHCOCK
From
DAVID O. SELZNICK
Based On the Novel
GONE WITH THE WIND
DAPHNE DU MAURIER
Released thru UNITED ARTISTS

Rebecca
U.S. (1940)
Selznick International
Releasing Studio: United
Artists

The Little Foxes
U.S. (1941)
Studio: RKO
Style "A"

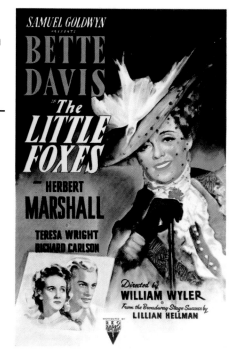

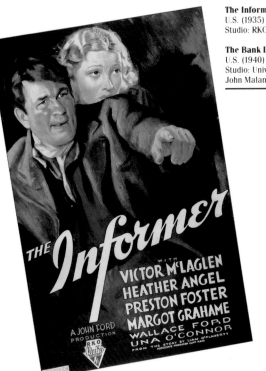

The Informer
U.S. (1935)
Studio: RKO

The Bank Dick
U.S. (1940)
Studio: Universal
John Malanga Collection

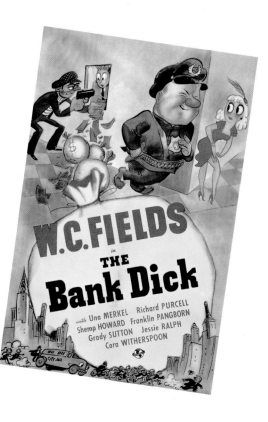

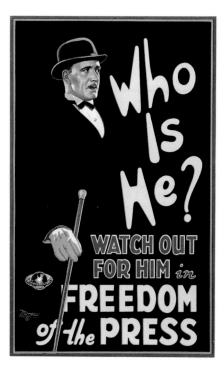

Freedom of the Press
U.S. (1928)
Studio: Universal

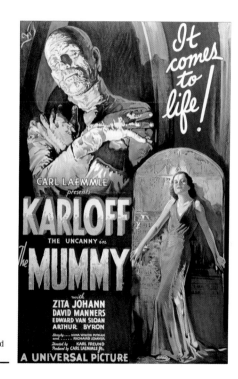

The Mummy
U.S. (1932)
Studio: Universal
Courtesy Neptune Blood
Smyth

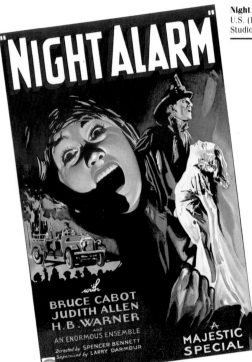

Night Alarm
U.S. (1934)
Studio: Majestic

Paradise Canyon
U.S. (1935)
Studio: Monogram

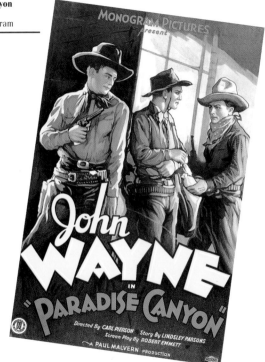

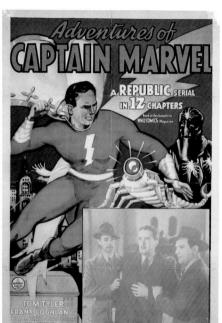

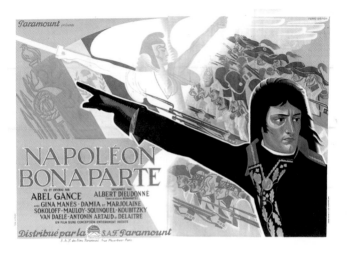

**The Adventures of
Captain Marvel**
U.S. (1941)
Studio: Republic
John Malanga Collection

Napoléon Bonaparte
U.S. title: **Napoleon**
France (1927)
Studio: WESTI/Société
Generale de Films

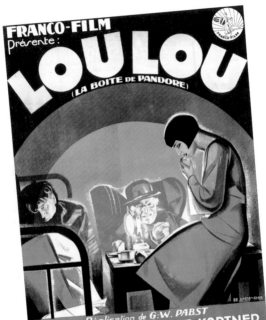

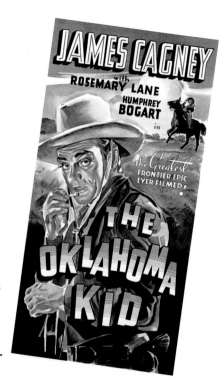

Lou-Lou
German title: **Die Busche der Pandora**
U.S. title: **Pandora's Box**
Germany (1929)
Studio: Nero Film

The Oklahoma Kid
U.S. (1939)
Studio: Warner Bros.

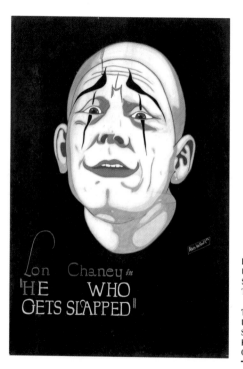

He Who Gets Slapped
U.S. (1924)
Studio: MGM
Todd Feiertag Collection

The Spoilers
U.S. (1930)
Studio: Paramount
Russell Roberts
Collection

Single-handed he fights the terrors of the Yukon

The Mightiest
of All Outdoor
Dramas.......

GARY
COOPER
in
Rex Beach's
"The SPOILERS"

Paramount
PICTURE

Kay Johnson, Betty Compson,
Harry Green, & James Kirkwood

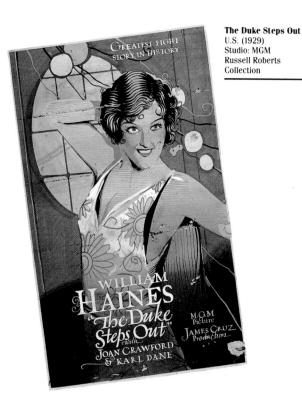

The Duke Steps Out
U.S. (1929)
Studio: MGM
Russell Roberts
Collection

**The Ten
Commandments**
U.S. (1923)
Studio: Paramount
Style "B"

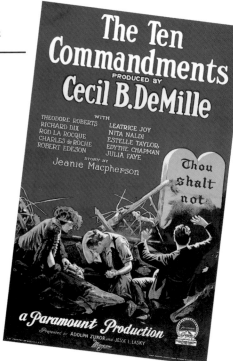

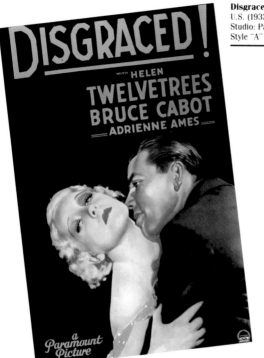

Disgraced!
U.S. (1933)
Studio: Paramount
Style "A"

THEY HAD FACES THEN

"You've got that little something extra that Ellen Terry talked about. She said that was what star quality was— that little something extra. Well, you've got it."

A Star Is Born *(1954)*

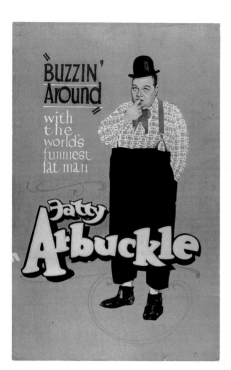

Buzzin' Around
U.S. (1934)
Studio: Vitagraph
Tony Goodstone
Collection

State's Attorney
U.S. (1932)
Studio: RKO
Ira Resnick Collection

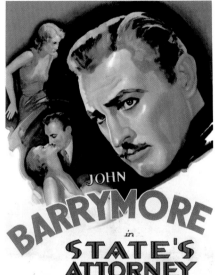

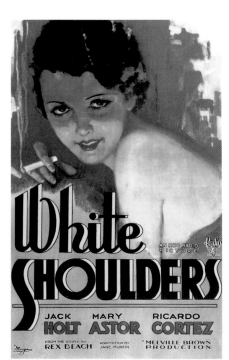

White Shoulders
U.S. (1931)
Studio: RKO

Hard to Handle
U.S. (1933)
Studio: Warner Bros.

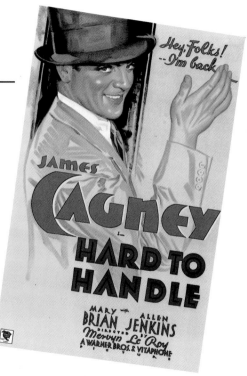

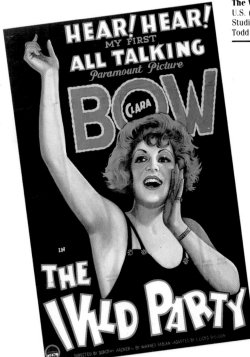

The Wild Party
U.S. (1929)
Studio: Paramount
Todd Feiertag Collection

Cruel, Cruel Love
U.S. (1914)
Studio: Keystone
John Malanga Collection

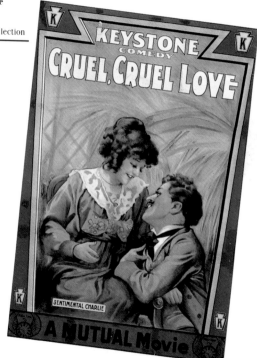

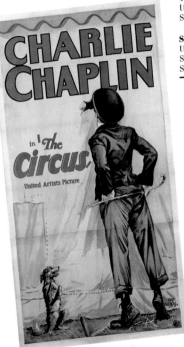

The Circus
U.S. (1928)
Studio: United Artists

She Married Her Boss
U.S. (1935)
Studio: Columbia
Style "A"

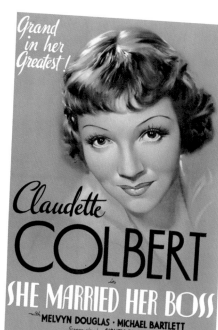

Grand
in her
Greatest!

Claudette
COLBERT

in

SHE MARRIED HER BOSS

with MELVYN DOUGLAS · MICHAEL BARTLETT

Screen play by SIDNEY BUCHMAN

A GREGORY LA CAVA PRODUCTION

A COLUMBIA PICTURE

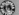

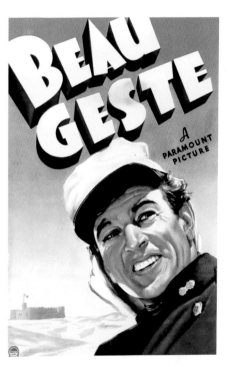

Beau Geste
U.S. (1939)
Studio: Paramount
Style "B"

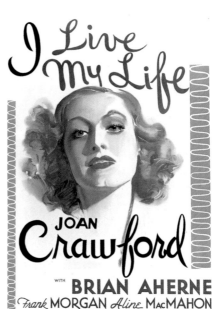

I Live My Life
U.S. (1935)
Studio: MGM
Style "D"

with
HENRY FONDA GEORGE BRENT
MARGARET LINDSAY DONALD CRISP FAY BAINTER

a WILLIAM WYLER production

A WARNER BROS. PICTURE

Jezebel
U.S. (1938)
Studio: Warner Bros.
Robert Bentley/Neptune
Blood Smyth Collection

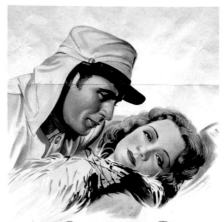

Morocco
U.S. (1930)
Studio: Paramount

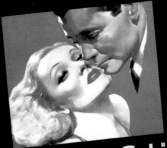

Angel
U.S. (1937)
Studio: Paramount
Style "A"

The Thief of Bagdad
U.S. (1924)
Studio: United Artists
Ira Resnick Collection

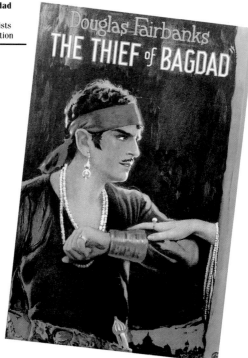

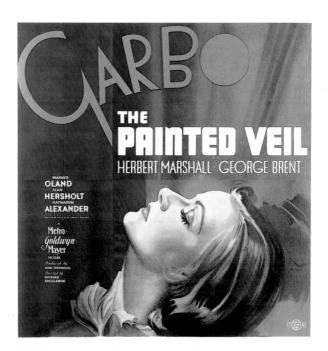

The Painted Veil
U.S. (1934)
Studio: MGM

Ninotchka
U.S. (1939)
Studio: MGM
Louis F. D'Elia Collection

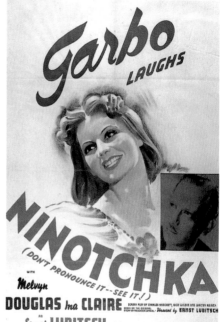

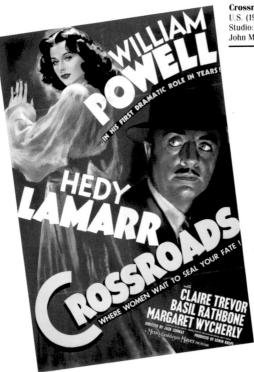

Crossroads
U.S. (1942)
Studio: MGM
John Malanga Collection

Feet of Mud
U.S. (1924)
Studio: Sennett-Pathé
Robert Bentley/Neptune
Blood Smyth Collection

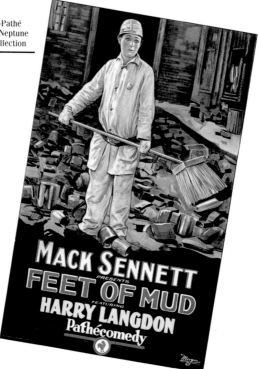

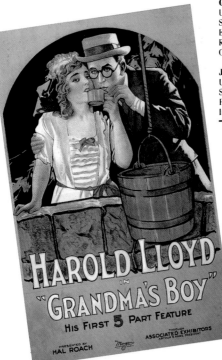

Grandma's Boy
U.S. (1922)
Studio: Associated
Exhibitors
Robert S. Birchard
Collection

Johanna Enlists
U.S. (1918)
Studio: Artcraft Pictures/
Paramount
Ira Resnick Collection

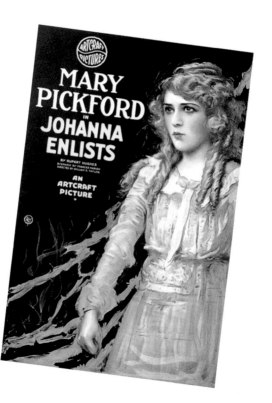

Lawyer Man
U.S. (1932)
Studio: Warner Bros.

WILLIAM
POWELL
in
Lawyer Man
with
JOAN BLONDELL
HELEN VINSON · ALAN DINEHART
DIRECTED BY WILLIAM DIETERLE
A WARNER BROS. & VITAPHONE
PICTURE

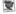

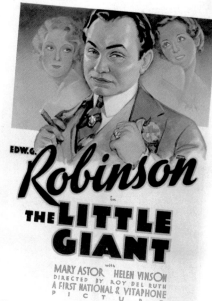

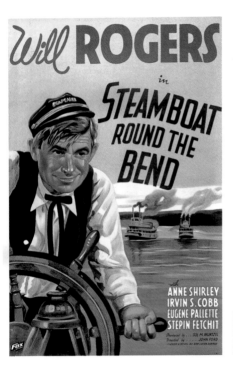

**Steamboat 'Round the
Bend**
U.S. (1935)
Studio: Fox

The Woman in Red
U.S. (1935)
Studio: First National

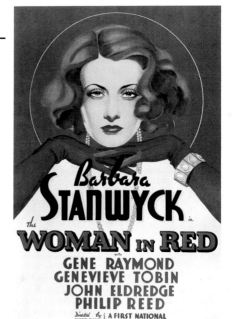

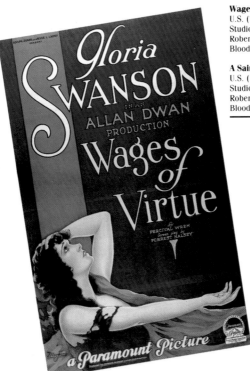

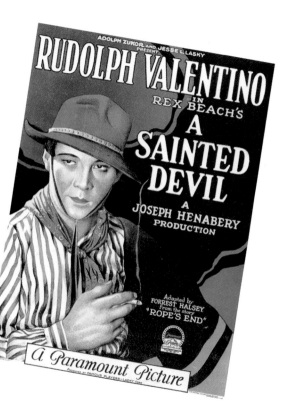

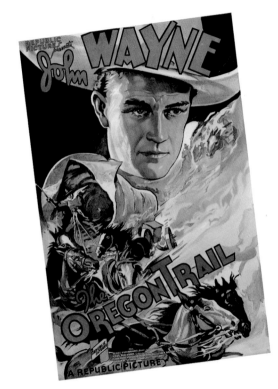

The Oregon Trail
U.S. (1936)
Studio: Republic

She Done Him Wrong
U.S. (1933)
Studio: Paramount

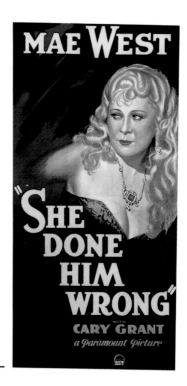

Three

LIGHTS, CAMERA... ADVENTURE!

*Armies and elephants . . .
Love and Laughter.
Breathless adventure
tuned to the rolling
thunder of red drumfire
in a land where men
fight to live, and women
love and weep!*

Gunga Din,
publicity (1939)

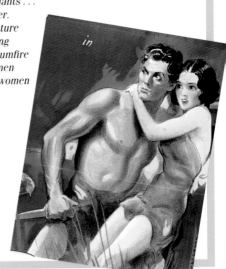

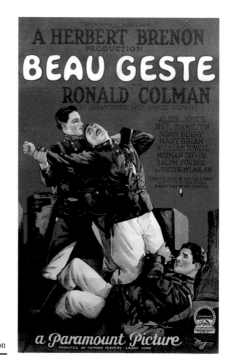

Beau Geste
U.S. (1926)
Studio: Paramount
Philip Shimkin Collection

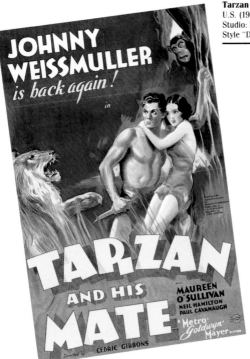

Tarzan and His Mate
U.S. (1934)
Studio: MGM
Style "D"

Call of the Wild
U.S. (1935)
Producing Studio:
Twentieth Century
Releasing Studio: United
Artists

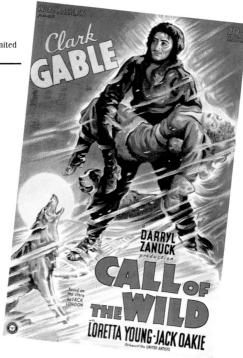

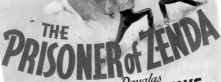

The Prisoner of Zenda
U.S. (1937)
Studio: Selznick
Releasing Studio: United
Artists

**The Adventures of
Robin Hood**
U.S. (1938)
Studio: Warner Bros.

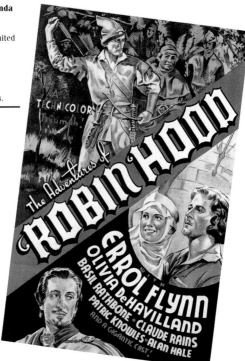

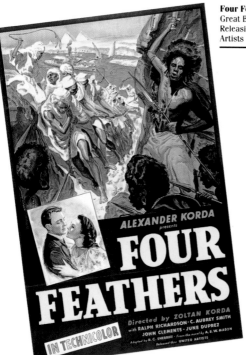

The Mark of Zorro
U.S. (1940)
Studio: 20th Century-Fox
Style "A"

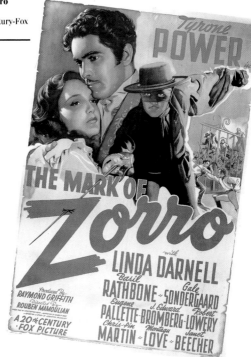

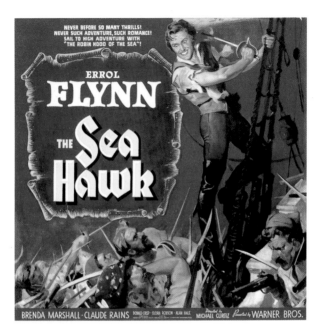

The Sea Hawk
U.S. (1940)
Studio: Warner Bros.
Matthew E. Schapiro
Collection

Gunga Din
U.S. (1939)
Studio: RKO

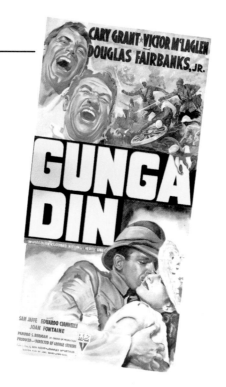

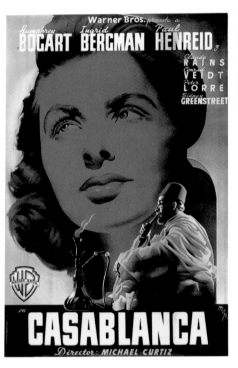

Casablanca
U.S. (1942)
Studio: Warner Bros.
Spanish poster

Casablanca
U.S. (1942)
Studio: Warner Bros.
French affiche

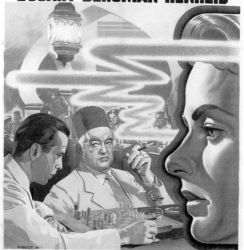

WARNER BROS. présente

HUMPHREY BOGART · INGRID BERGMAN · PAUL HENREID

DANS

CASABLANCA

AVEC
CLAUDE RAINS · CONRAD VEIDT · SYDNEY GREENSTREET · PETER LORRE

Production de HAL B. WALLIS Réalisation de MICHAEL CURTIZ
Musique de Max STEINER

KARTOON KARNIVAL

"Walt Disney has the ideal situation. If he doesn't like an actor, he just tears him up."

Alfred Hitchcock

Flowers and Trees
U.S. (1932)
Distributor: United
Artists
© 1932 The Walt Disney
Company

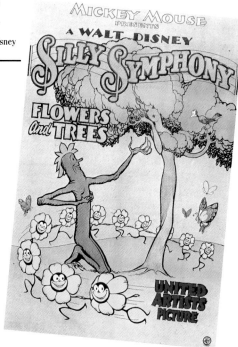

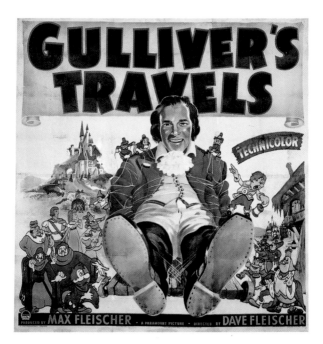

Gulliver's Travels
U.S. (1939)
Studio: Paramount
Kirby McDaniel
Collection

Pinocchio
U.S. (1940)
Distributor: RKO
© 1940 The Walt Disney
Company

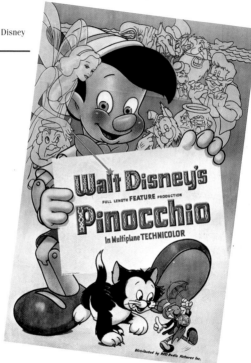

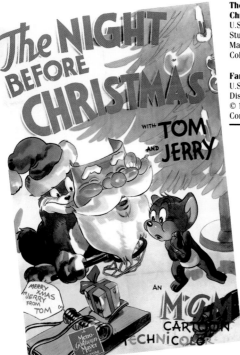

The Night Before Christmas
U.S. (1941)
Studio: MGM
Matthew E. Schapiro
Collection

Fantasia
U.S. (1940)
Distributor: RKO
© 1940 The Walt Disney
Company

Walt Disney's

TECHNICOLOR *FEATURE* TRIUMPH

FANTASIA

with

Stokowski

Distributed by RKO Radio Pictures, Inc.

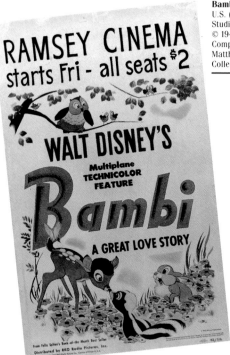

Bambi
U.S. (1942)
Studio: Walt Disney/RKO
© 1942 The Walt Disney Company
Matthew E. Schapiro Collection

LAUGHTER IN THE DARK

"There's a lot to be said for making people laugh. Did you know that's all some people have? It isn't much, but it's better than nothing in this cockeyed caravan!"

Sullivan's Travels
(1941)

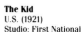

The Kid
U.S. (1921)
Studio: First National

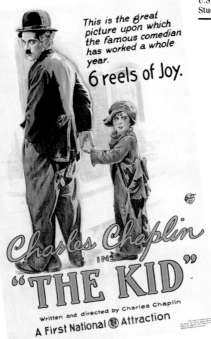

Bacon Grabbers
U.S. (1929)
Studio: MGM

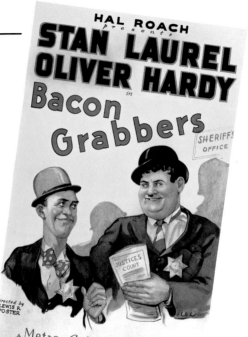

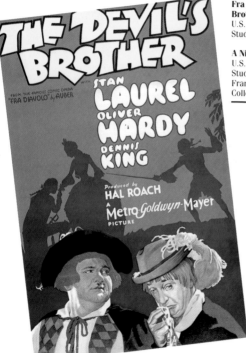

Fra Diavalo/The Devil's Brother
U.S. (1933)
Studio: MGM

A Night at the Opera
U.S. (1935)
Studio: MGM
Frank M. Di Andrea
Collection

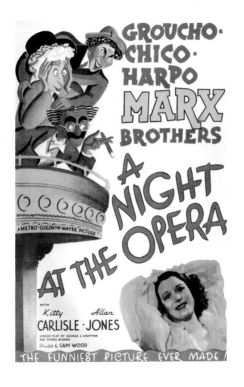

A Day at the Races
U.S. (1937)
Studio: MGM
Todd Feiertag Collection

THE YEAR'S BIG LAUGH, MUSIC AND GIRL SHOW!

MARX BROS.

GROUCHO CHICO HARPO

in

A DAY AT THE RACES

with

ALLAN JONES

Maureen O'SULLIVAN

A SAM WOOD PRODUCTION A Metro-Goldwyn-Mayer PICTURE PRODUCED BY LAWRENCE WEINGARTEN

The Kid from Borneo
U.S. (1933)
Studio: MGM
Matthew E. Schapiro
Collection

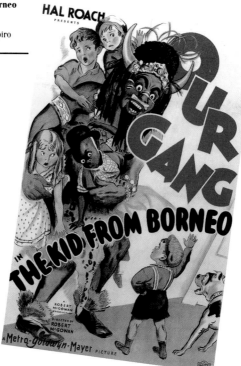

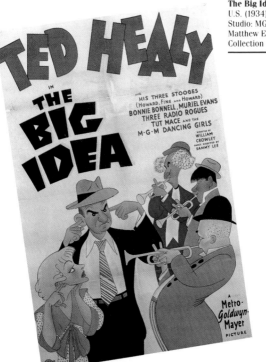

The Big Idea
U.S. (1934)
Studio: MGM
Matthew E. Schapiro
Collection

It's a Gift
U.S. (1934)
Studio: Paramount
Library of Congress
Collection

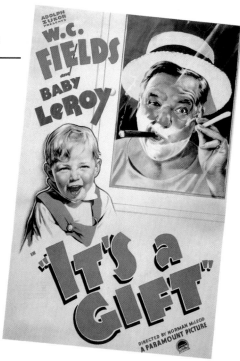

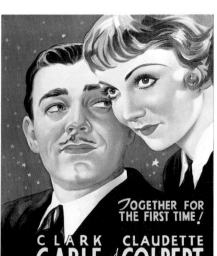

TOGETHER FOR
THE FIRST TIME!

CLARK CLAUDETTE
GABLE and COLBERT

in

"It Happened One Night"

with ★ WALTER CONNOLLY ★ ROSCOE KARNS

From the Cosmopolitan Magazine story by SAMUEL HOPKINS ADAMS ★ Screen play by ROBERT RISKIN

 a FRANK CAPRA PRODUCTION A COLUMBIA PICTURE

It Happened One Night
U.S. (1934)
Studio: Columbia
Style "B"

Mr. Deeds Goes to Town
U.S. (1936)
Studio: Columbia

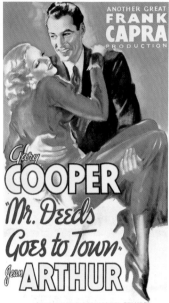

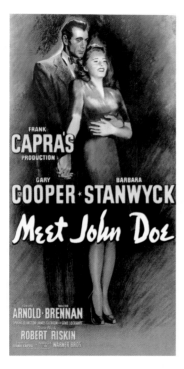

Meet John Doe
U.S. (1941)
Studio: Warner Bros.

It's a Wonderful Life
U.S. (1946)
Studio: Liberty/RKO
Matthew E. Schapiro
Collection

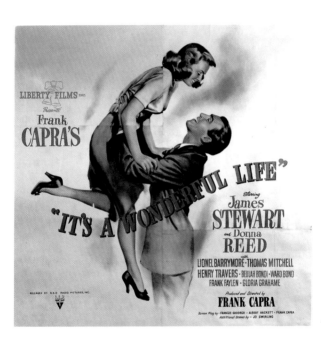

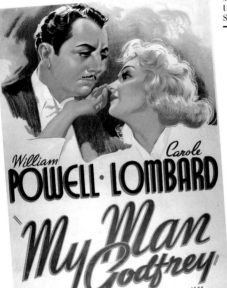

The Shop Around the Corner
U.S. (1940)
Studio: MGM
Style "D"
Louis F. D'Elia Collection

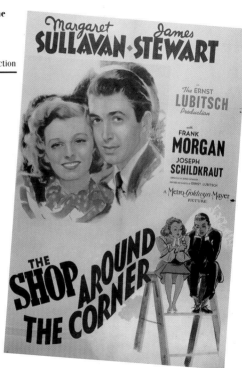

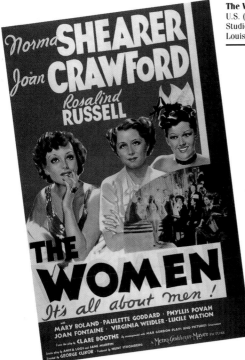

The Women
U.S. (1939)
Studio: MGM
Louis F. D'Elia Collection

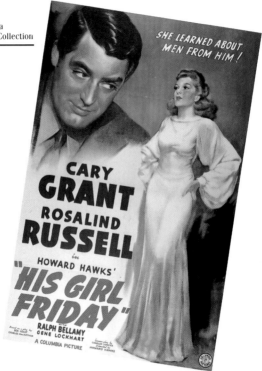

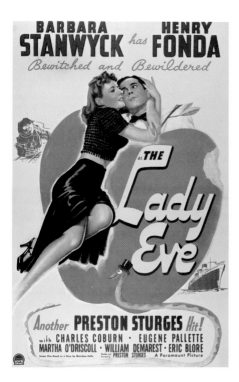

The Lady Eve
U.S. (1941)
Studio: Paramount

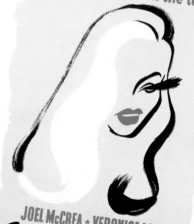

Veronica Lake's on the take

JOEL McCREA ★ VERONICA LAKE

SULLIVAN'S TRAVELS

A Paramount Picture with
ROBERT WARWICK · WILLIAM DEMAREST · MARGARET HAYES
PORTER HALL · FRANKLIN PANGBORN · ERIC BLORE

Written and Directed by PRESTON STURGES

YOU ARE THERE

*"When the legend becomes fact,
print the legend."*

The Man Who Shot
Liberty Valance *(1962)*

Nanook of the North
U.S. (1922)
Releasing Company:
Revillon Frères/Pathé
Louis F. D'Elia Collection

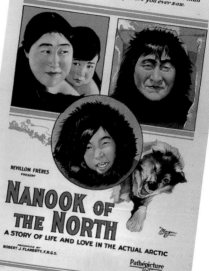

The Bull-Dogger
U.S. (1923)
Studio: Norman Film
Manufacturing Company

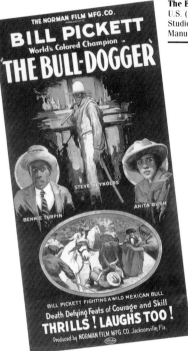

Ingagi
U.S. (1931)
Studio: Congo Pictures/
RKO

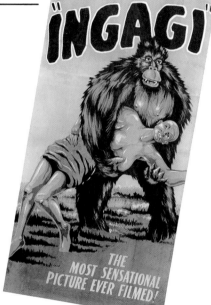

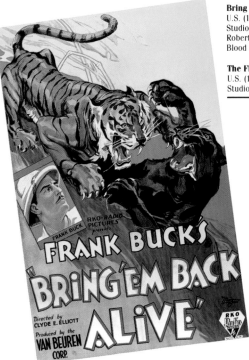

Bring 'Em Back Alive
U.S. (1932)
Studio: RKO
Robert Bentley/Neptune
Blood Smyth Collection

The Flying Irishman
U.S. (1939)
Studio: RKO

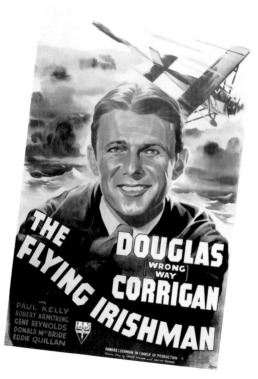

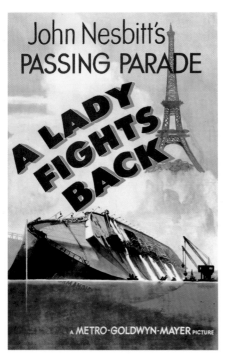

A Lady Fights Back
U.S. (1944)
Studio: MGM

DRAMARAMA

*Real life screened more daringly
than it's ever been before!*

The Magnificent Ambersons,
publicity (1942)

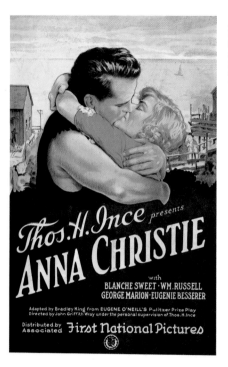

Anna Christie
U.S. (1923)
Studio: First National/
Associated
Robert S. Birchard
Collection

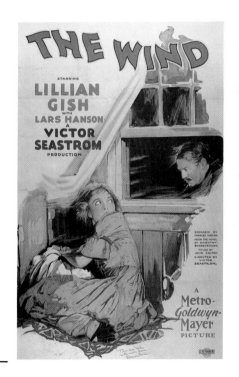

The Wind
U.S. (1928)
Studio: MGM
Michael Kaplan
Collection

The Girl from Chicago
U.S. (1932)
Studio: Oscar Micheaux

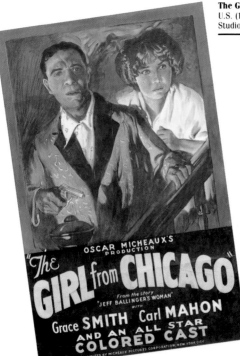

David Copperfield
U.S. (1935)
Studio: MGM
Ira Resnick Collection

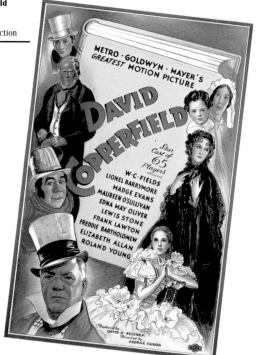

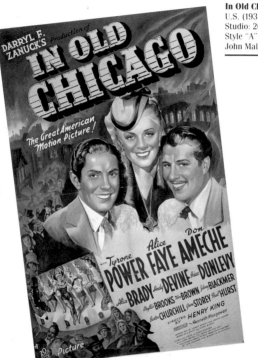

In Old Chicago
U.S. (1937)
Studio: 20th Century-Fox
Style "A"
John Malanga Collection

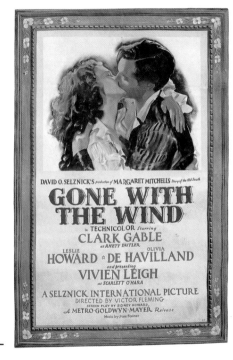

Gone with the Wind
U.S. (1939)
Studio: MGM/Selznick
International
Style "DF"
Courtesy José Ma.
Carpio/Cinemonde,
San Francisco

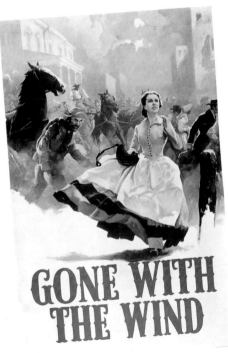

GONE WITH THE WIND

Gone with the Wind
U.S. (1939)
Studio: MGM/Selznick
International
Style "CP"

Gone with the Wind
U.S. (1939)
Studio: MGM/Selznick
International
Style "F"
Ira Resnick Collection

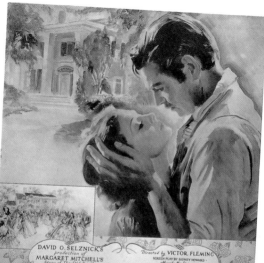

DAVID O. SELZNICK'S
production of
MARGARET MITCHELL'S
Story of The Old South

Directed by VICTOR FLEMING
SCREEN PLAY BY SIDNEY HOWARD
Music by Max Steiner

GONE WITH THE WIND
IN TECHNICOLOR

Starring CLARK GABLE
AS RHETT BUTLER

Leslie HOWARD · Olivia DE HAVILLAND

and presenting
VIVIEN LEIGH
AS SCARLETT O'HARA

A SELZNICK INTERNATIONAL PICTURE
A METRO-GOLDWYN-MAYER Release

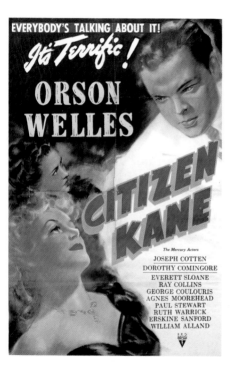

Citizen Kane
U.S. (1941)
Studio: RKO
Style "B"
Philip Shimkin Collection

HISTORY, HOLLYWOOD STYLE

*"You're better than news.
You're history."*
Viva Villa! *(1934)*

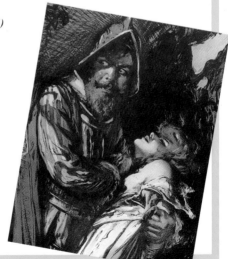

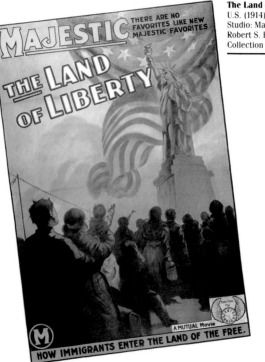

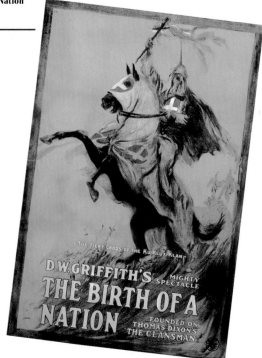

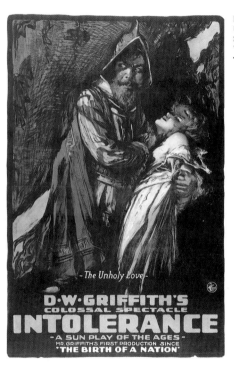

The Unholy Love

D·W·GRIFFITH'S
COLOSSAL SPECTACLE
INTOLERANCE
-A SUN PLAY OF THE AGES-
MR. GRIFFITH'S FIRST PRODUCTION SINCE
"THE BIRTH OF A NATION"

Intolerance
U.S. (1916)
Studio: D. W. Griffith/
Wark

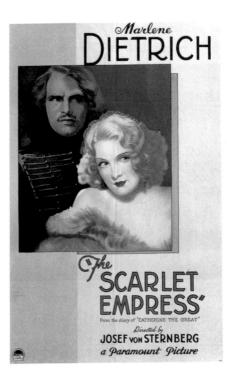

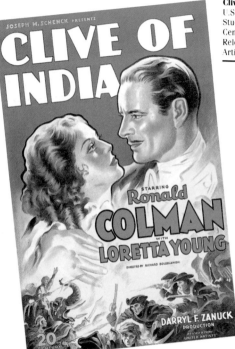

Clive of India
U.S. (1935)
Studio: Twentieth
Century
Releasing Studio: United
Artists

The Last Days of Pompeii
U.S. (1935)
Studio: RKO

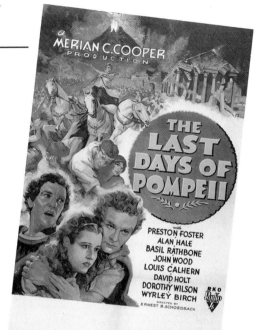

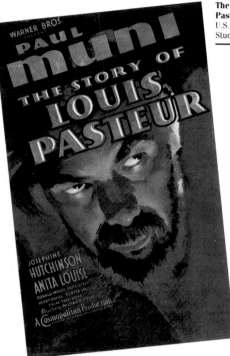

The Story of Louis Pasteur
U.S. (1936)
Studio: Warner Bros.

Victoria the Great
Great Britain (1937)
U.S. release poster
Studio: RKO

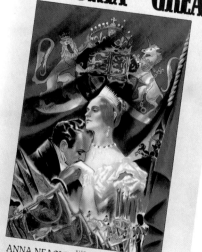

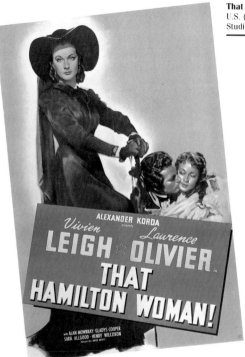

Drums along the Mohawk
U.S. (1939)
Studio: 20th Century-Fox
Style "A"

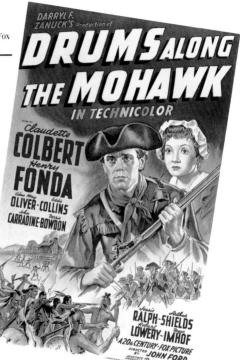

SHRIEKS, FUTURE SHOCKS, AND DAYDREAMS

A monster in form but human in his desire for love!

The Bride of Frankenstein, *publicity (1935)*

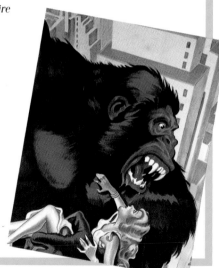

The Phantom of the Opera
U.S. (1926)
Studio: Universal
Philip Shimkin Collection

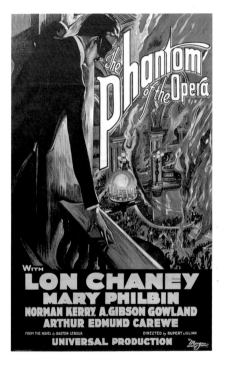

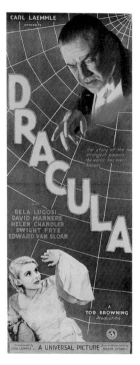

Dracula
U.S. (1931)
Studio: Universal
Courtesy José Ma.
Carpio/Cinemonde.
San Francisco

Frankenstein
U.S. (1931)
Studio: Universal
Courtesy Larry Edmunds
Bookshop, Hollywood

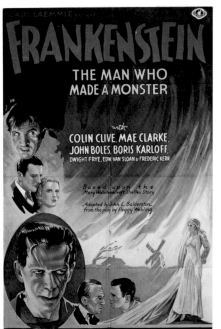

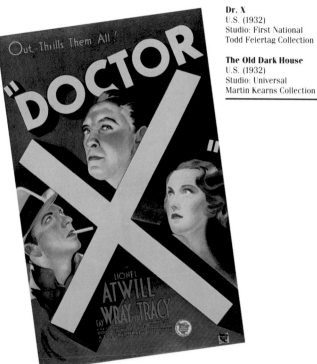

Dr. X
U.S. (1932)
Studio: First National
Todd Feiertag Collection

The Old Dark House
U.S. (1932)
Studio: Universal
Martin Kearns Collection

FIVE persons in the house . . . strangers cut off from the world by thunderstorms and landslide . . . Terror of the unknown draws them together . . . makes them open their pasts to each other . . . Then, as the excitement reaches its peak, when the girl, alone on the stairs, finds the drunken monster lurching toward her — — —

Man, this is a MYSTERY story . . . A SUSPENSE story . . . A BOX-OFFICE story, featuring A GREAT CAST HEADED BY

BORIS
KARLOFF
MELVIN
DOUGLAS

The
OLD
DARK
HOUSE

from the novel by
J. B. PRIESTLEY

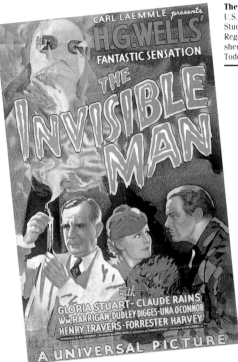

The Invisible Man
U.S. (1933)
Studio: Universal
Regular release one-sheet
Todd Feiertag Collection

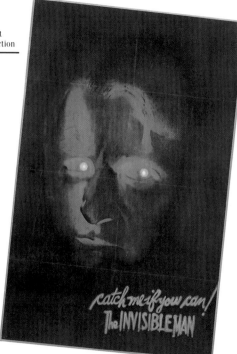

King Kong
U.S. (1933)
Studio: RKO
French affiche

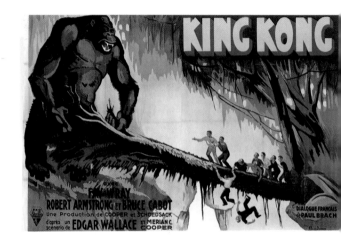

King Kong
U.S. (1933)
Studio: RKO
Style "A"

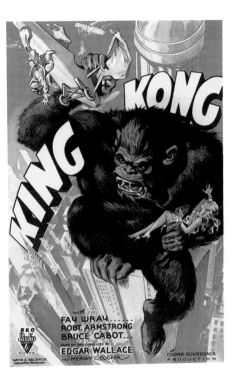

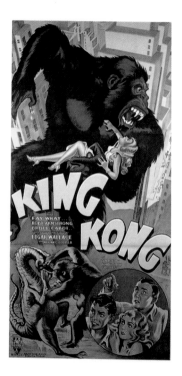

King Kong
U.S. (1933)
Studio: RKO
Courtesy José Ma.
Carpio/Cinemonde,
San Francisco

King Kong
U.S. (1933)
Studio: RKO
Czechoslovakian plakat

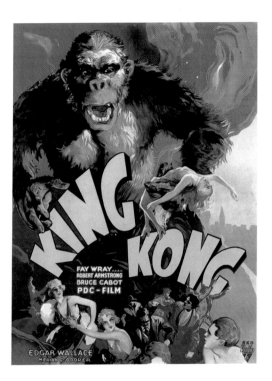

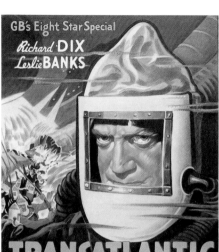

Transatlantic Tunnel
Great Britain (1935)
British title: **The Tunnel**
U.S. release poster
Studio: Gaumont-British

Condemned to Live
U.S. (1935)
Studio: Invincible
Pictures/Chesterfield

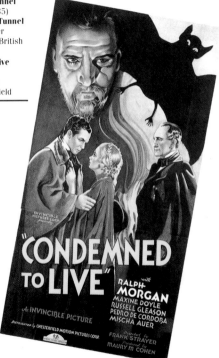

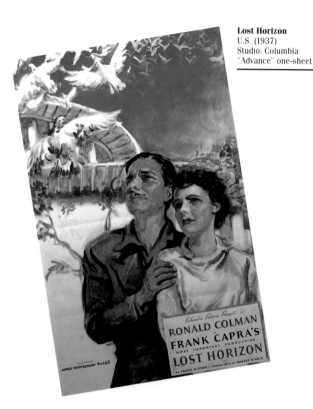

Lost Horizon
U.S. (1937)
Studio: Columbia
"Advance" one-sheet

**The Hunchback of
Notre Dame**
U.S. (1939)
Studio: RKO

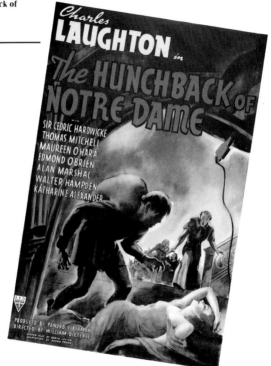

Charles LAUGHTON in

THE HUNCHBACK of NOTRE DAME

SIR CEDRIC HARDWICKE
THOMAS MITCHELL
MAUREEN O'HARA
EDMOND O'BRIEN
ALAN MARSHAL
WALTER HAMPDEN
KATHARINE ALEXANDER

PRODUCED BY PANDRO S. BERMAN
DIRECTED BY WILLIAM DIETERLE

The Wizard of Oz
U.S. (1939)
Studio: MGM
Matthew E. Schapiro
Collection

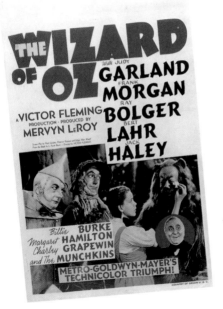

One Million B.C.
U.S. (1940)
Studio: Hal Roach/United Artists

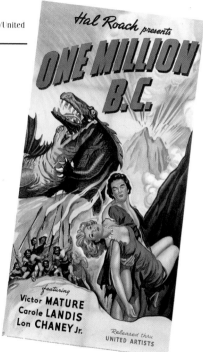

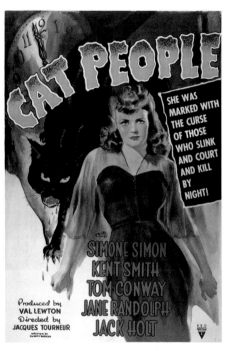

Cat People
U.S. (1942)
Studio: RKO

The Body Snatcher
U.S. (1945)
Studio: RKO
Style "A"

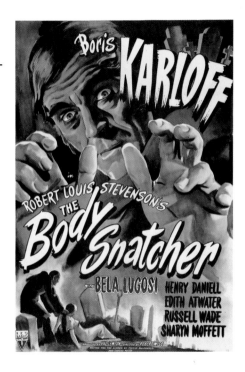

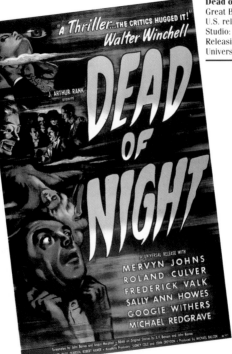

Dead of Night
Great Britain (1945)
U.S. release poster
Studio: Ealing
Releasing Studio:
Universal

LET'S FACE THE MUSIC

*A dream-drenched story
of Paris at love time . . .
with heart-breaking
beauties in gasping gowns!
All your life you'll
TINGLE to its
heart-disturbing tunes!
SO WONDERFUL
YOU CAN'T BELIEVE
IT'S REAL!*

Roberta,
publicity (1935)

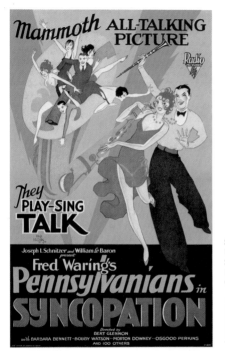

Syncopation
U.S. (1929)
Studio: Radio
Robert S. Birchard Collection

Hallelujah!
U.S. (1929)
Studio: MGM
Martin Kearns Collection

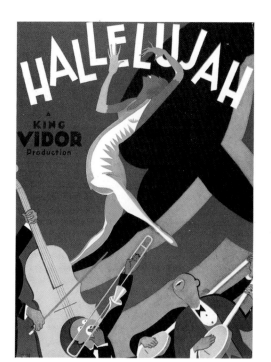

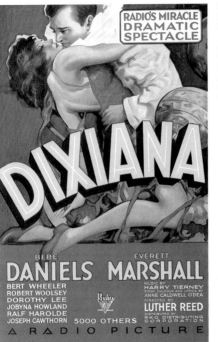

Dixiana
U.S. (1930)
Studio: RKO

42nd Street
U.S. (1933)
Studio: Warner Bros.
Matthew E. Schapiro
Collection

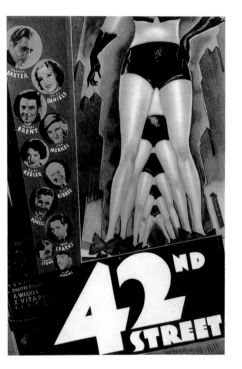

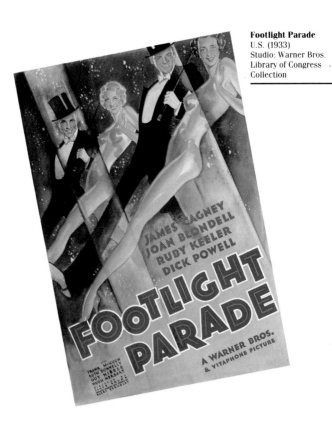

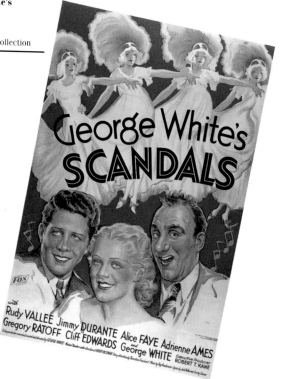

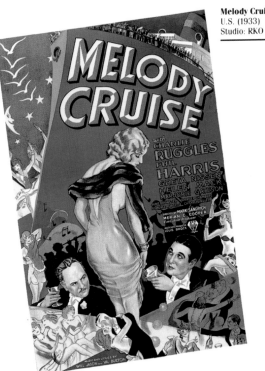

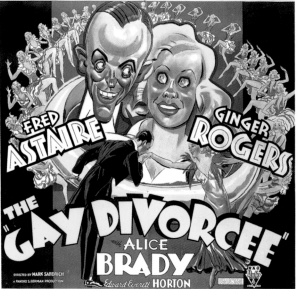

The Gay Divorcee
U.S. (1934)
Studio: RKO

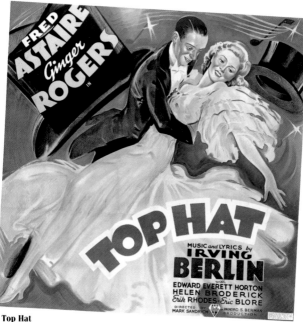

Top Hat
U.S. (1935)
Studio: RKO
27 x 41"/69 x 104 cm.
Matthew E. Schapiro
Collection

Top Hat
U.S. (1935)
Studio: RKO
81 x 81"/205 x 205 cm.












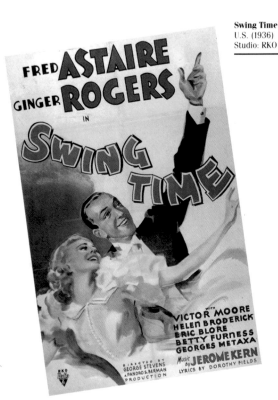

Swing Time
U.S. (1936)
Studio: RKO

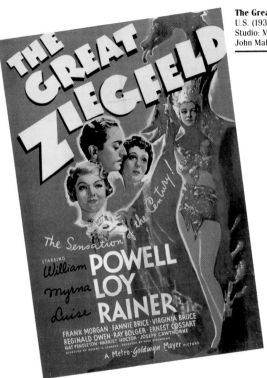

The Great Ziegfeld
U.S. (1936)
Studio: MGM
John Malanga Collection

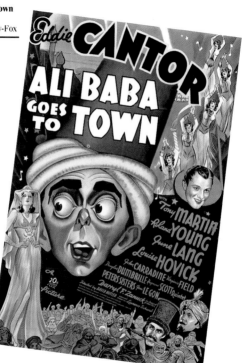

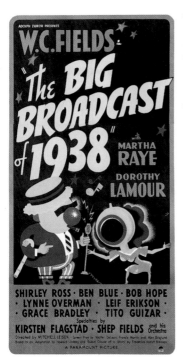

The Big Broadcast of 1938
U.S. (1938)
Studio: Paramount
Style "A"

Ziegfeld Follies
U.S. (1946)
Studio: MGM

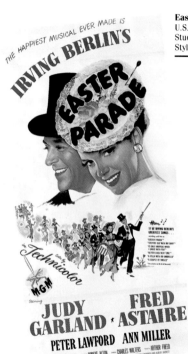

Easter Parade
U.S. (1948)
Studio: MGM
Style "B"

GANGSTERS, GANGBUSTERS, AND NAIL BITERS

He runs the gamut of power—from gutter to gang ruler—to gutter again!

Little Caesar, publicity (1930)

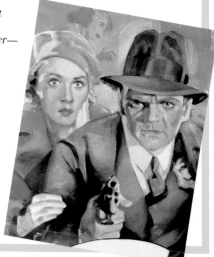

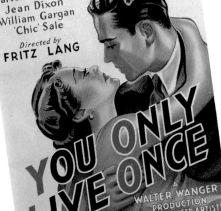

You Only Live Once
U.S. (1937)
Studio: United Artists/
Walter Wanger

**The Amazing Dr.
Clitterhouse**
U.S. (1938)
Studio: Warner Bros.

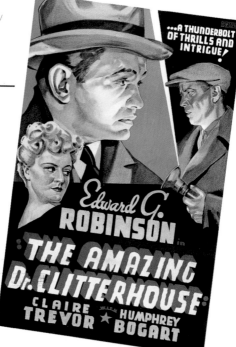

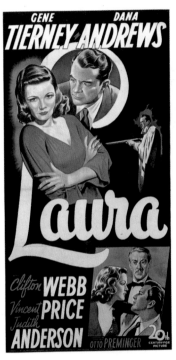

Laura
U.S. (1944)
Studio: 20th Century-Fox

Double Indemnity
U.S. (1944)
Studio: Paramount
Matthew E. Schapiro
Collection

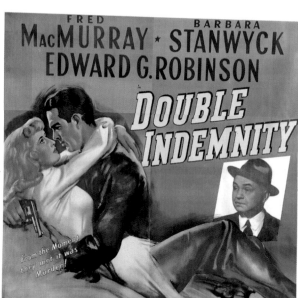

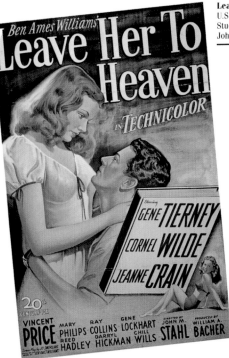

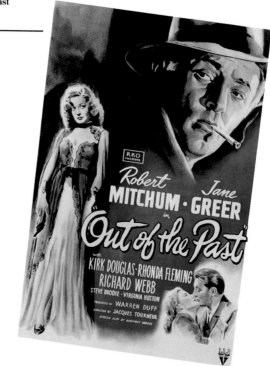

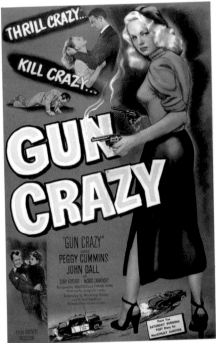

Gun Crazy
U.S. (1950)
Originally released as
Deadly Is the Female
Studio: United Artists
Louis F. D'Elia Collection

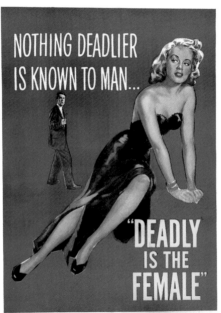

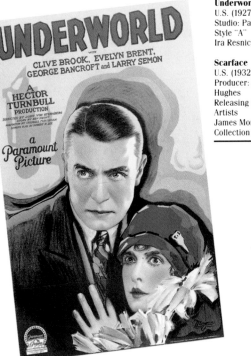

Underworld
U.S. (1927)
Studio: Paramount
Style "A"
Ira Resnick Collection

Scarface
U.S. (1932)
Producer: Howard
Hughes
Releasing Studio: United
Artists
James Morgan Watters
Collection

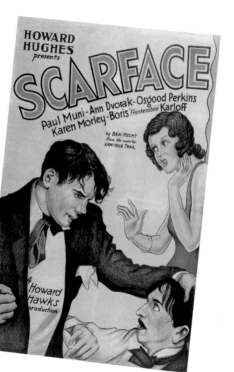

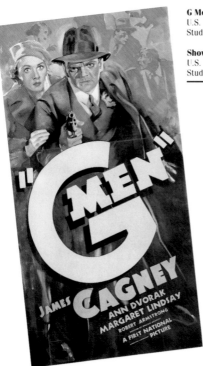

G Men
U.S. (1935)
Studio: Warner Bros.

Show Them No Mercy
U.S. (1935)
Studio: 20th Century-Fox

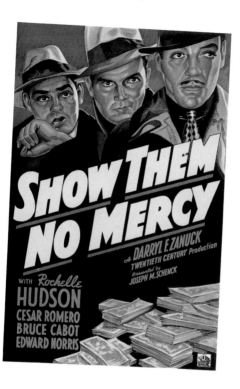

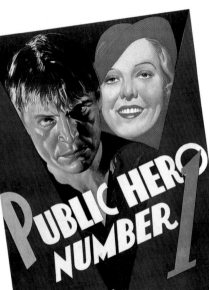

Public Hero Number One
U.S. (1935)
Studio: MGM
Style "D"

San Quentin
U.S. (1937)
Studio: Warner Bros.

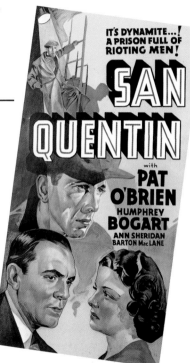

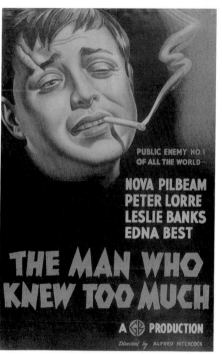

The Man Who Knew Too Much
Great Britain (1934)
U.S. release poster
Studio: Gaumont-British
American Distributor:
20th Century-Fox

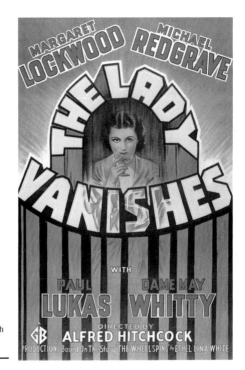

The Lady Vanishes
Great Britain (1938)
U.S. release poster
Studio: Gaumont-British
American Distributor:
20th Century-Fox

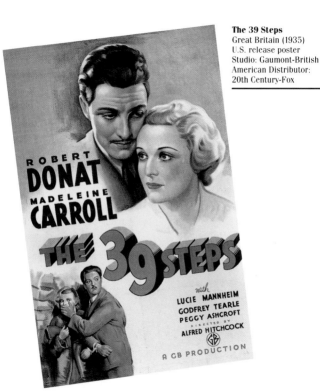

The 39 Steps
Great Britain (1935)
U.S. release poster
Studio: Gaumont-British
American Distributor:
20th Century-Fox

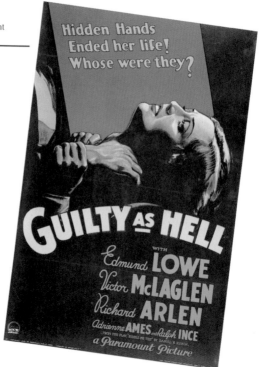

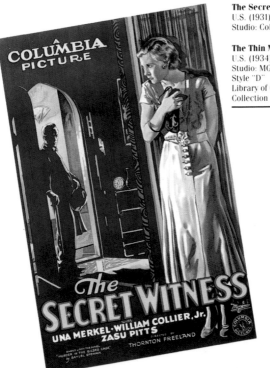

The Secret Witness
U.S. (1931)
Studio: Columbia

The Thin Man
U.S. (1934)
Studio: MGM
Style "D"
Library of Congress
Collection

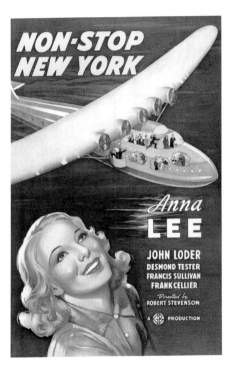

Non-Stop New York
U.S. (1937)
Studio: Gaumont-British

The Hound of the Baskervilles
U.S. (1939)
Studio: 20th Century-Fox
Todd Feiertag Collection

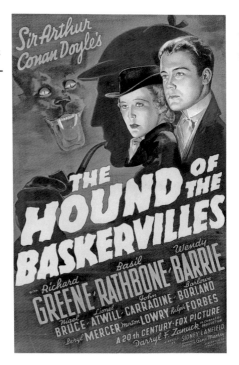

SPORTS, ILLUSTRATED

*"Go out there and win one
for the Gipper!"*
Knute Rockne, All American
(1940)

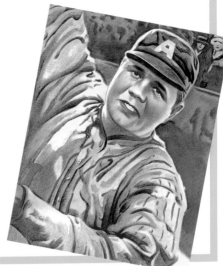

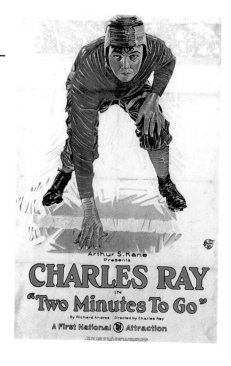

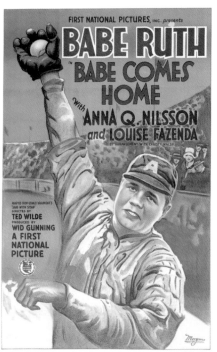

Babe Comes Home
U.S. (1927)
Studio: First National
Ira Resnick Collection

The Big Game
U.S. (1936)
Studio: RKO

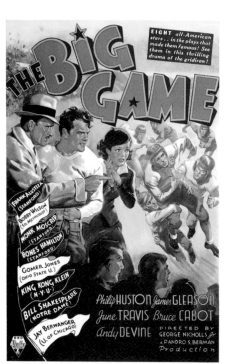

Thirteen

PASS THE AMMUNITION

"We live in the trenches out there.
We fight. We try not to be killed,
but sometimes we are—that's all."

All Quiet on the
Western Front
(1930)

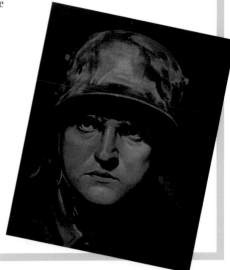

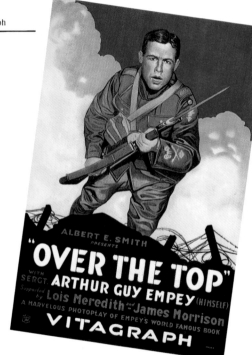

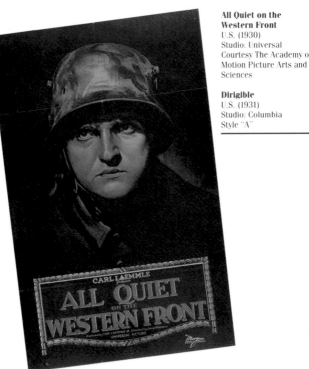

All Quiet on the Western Front
U.S. (1930)
Studio: Universal
Courtesy The Academy of Motion Picture Arts and Sciences

Dirigible
U.S. (1931)
Studio: Columbia
Style "A"

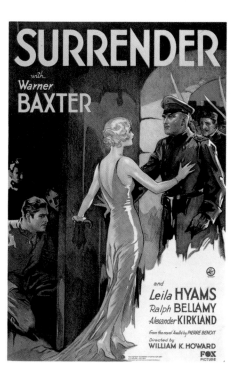

Surrender
U.S. (1931)
Studio: Fox

Devil Dogs of the Air
U.S. (1935)
Studio: Warner Bros.

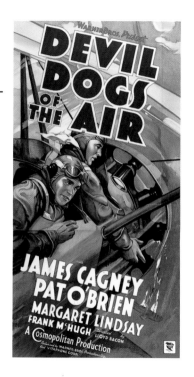

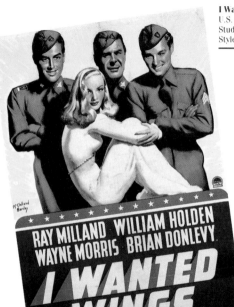

I Wanted Wings
U.S. (1941)
Studio: Paramount
Style "B"

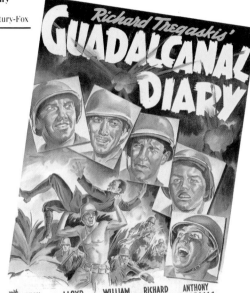

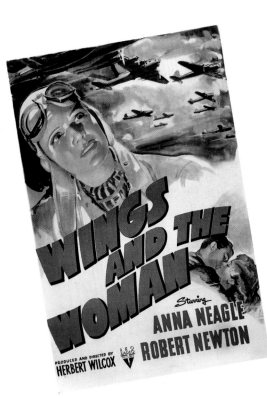

Wings and the Woman
Great Britain (1942)
British title: **They Flew Alone**
U.S. release poster
Studio: RKO
Style "A"

Lifeboat
U.S. (1944)
Studio: 20th Century-Fox

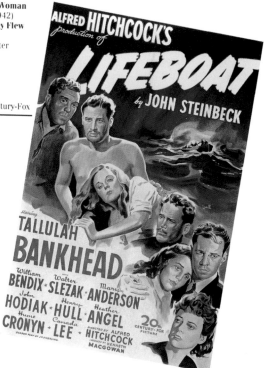

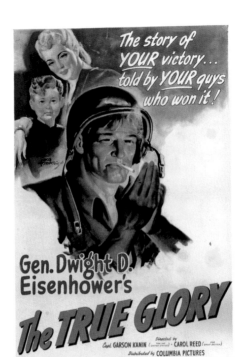

The True Glory
U.S. (1945)
Releasing Studio:
Columbia

Desert Victory
U.S. (1943)
Studio: 20th Century-Fox

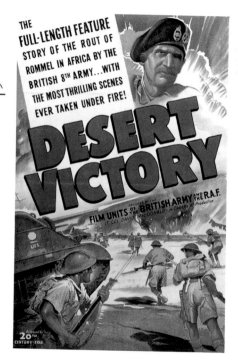

THE FULL-LENGTH FEATURE STORY OF THE ROUT OF ROMMEL IN AFRICA BY THE BRITISH 8TH ARMY...WITH THE MOST THRILLING SCENES EVER TAKEN UNDER FIRE!

DESERT VICTORY

PRODUCED BY THE FILM UNITS OF THE BRITISH ARMY AND THE R.A.F.
LT COL. DAVID MACDONALD—In Charge of Production

20TH CENTURY-FOX

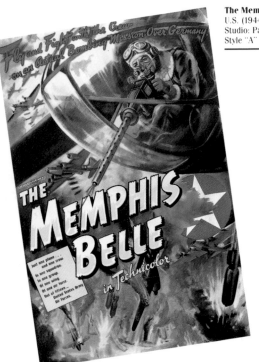

The Memphis Belle
U.S. (1944)
Studio: Paramount
Style "A"

Fourteen

THEY WENT THAT-A-WAY

The click of guns—
the clink of glasses,
the creak of leather—
the murmur of
mountain streams!
Riding! Fighting!
Red Blood Romance!

Driftin' Thru (1926)

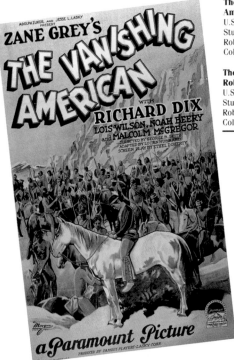

The Vanishing American
U.S. (1925)
Studio: Paramount
Robert S. Birchard
Collection

The Great K & A Train Robbery
U.S. (1926)
Studio: Selig
Robert S. Birchard
Collection

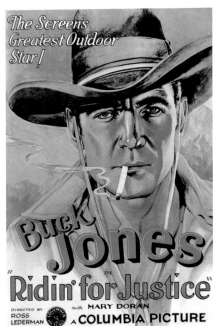

Ridin' for Justice
U.S. (1932)
Studio: Columbia

Cimarron
U.S. (1931)
Studio: RKO
Courtesy The Academy of
Motion Picture Arts and
Sciences

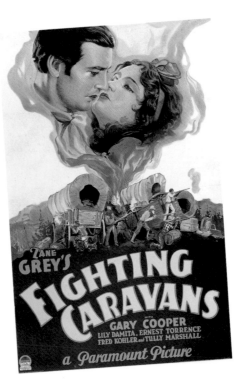

Fighting Caravans
U.S. (1931)
Studio: Paramount
Style "B"

The Golden West
U.S. (1932)
Studio: Fox

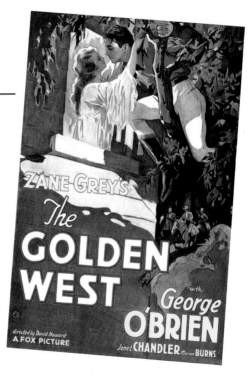

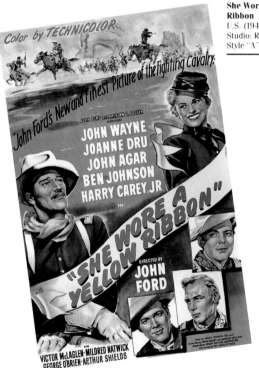

She Wore a Yellow Ribbon
U.S. (1949)
Studio: RKO/Argosy
Style "A"

Stagecoach
U.S. (1939)
Walter Wanger
Productions
Releasing Studio: United
Artists

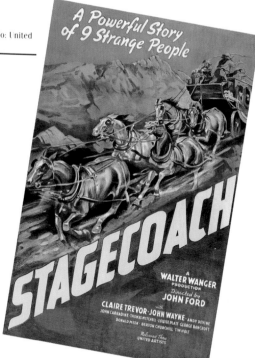

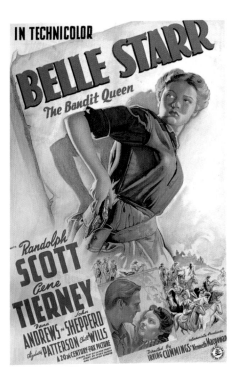

Belle Starr
U.S. (1941)
Studio: 20th Century-Fox
Style "A"

The Ox-Bow Incident
U.S. (1943)
Studio: 20th Century-Fox

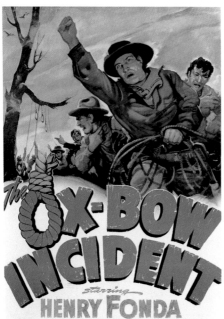

THE OX-BOW INCIDENT

starring

HENRY FONDA

Dana ANDREWS ★ Mary Beth HUGHES

directed by WILLIAM A. WELLMAN ★ produced and written by LAMAR TROTTI 20th CENTURY-FOX PICTURE

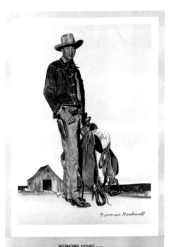

Along Came Jones
U.S. (1945)
Studio: RKO/International
Style "A"

CRIES AND WHISPERS

*"Oh, Jerry, don't let's
ask for the moon.
We have the stars!"*
Now Voyager *(1942)*

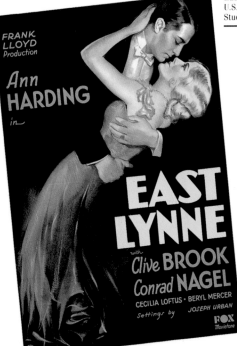

FRANK
LLOYD
Production

Ann
HARDING

in

EAST
LYNNE

with Clive BROOK
Conrad NAGEL

CECILIA LOFTUS · BERYL MERCER

settings by JOSEPH URBAN

FOX
Movietone

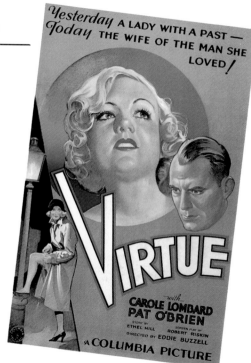

Bitter Sweet
Great Britain (1933)
U.S. release poster
Studio: United Artists

Our Betters
U.S. (1933)
Studio: RKO

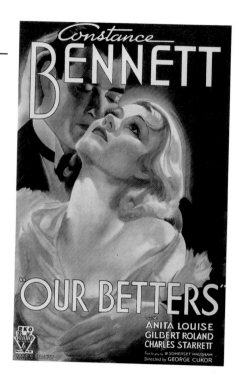

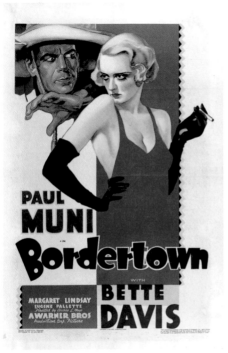

Bordertown
U.S. (1934)
Studio: Warner Bros.

The Golden Arrow
U.S. (1936)
Studio: Warner Bros.
Robert Bentley/Neptune
Blood Smyth Collection

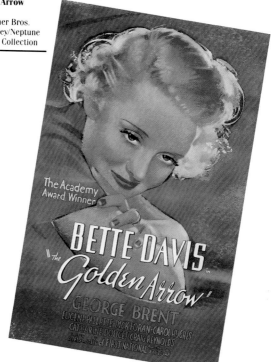

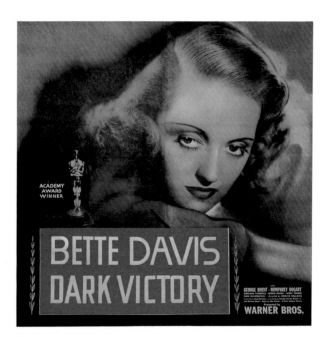

Dark Victory
U.S. (1939)
Studio: Warner Bros.
Ira Resnick Collection

Dr. Monica

U.S. (1934)

Studio: Warner Bros.

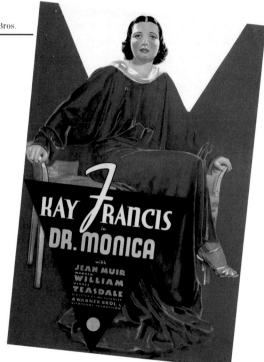

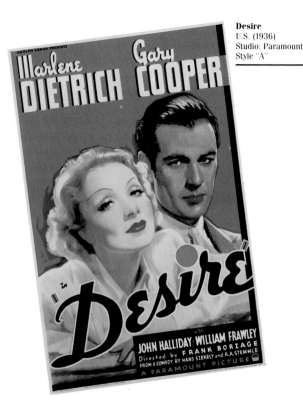

Desire
U.S. (1936)
Studio: Paramount
Style "A"

Fifth Avenue Girl
.S. (1939)
tudio: RKO

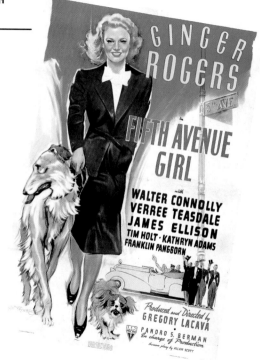

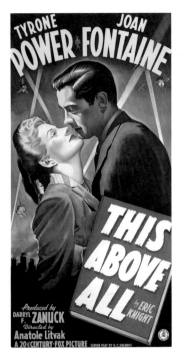

This Above All
U.S. (1942)
Studio: 20th Century-Fox
Style "A"

FADS, FOLLIES, AND FOIBLES

Annie for Spite
U.S. (1917)
Studio: American Film
Company
Robert S. Birchard
Collection

The Girl He Didn't Buy
U.S. (1928)
Studio: Peerless

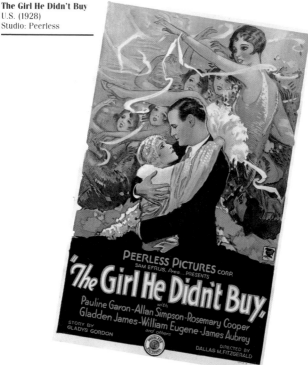

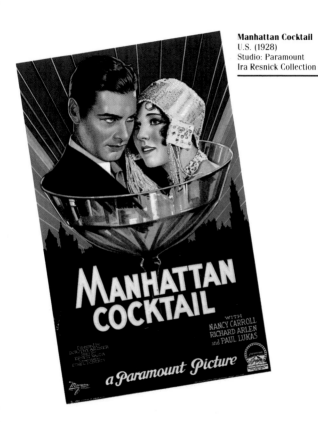

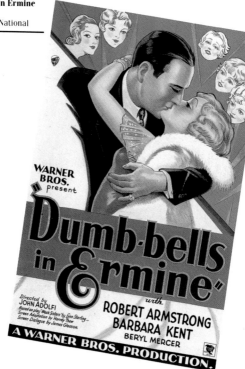

WARNER
BROS.
present

"Dumb-bells
in Ermine"

Directed by
JOHN ADOLFI
Based on play Weak Sisters by Geo Sterling
Screen Adaptation by Harvey Thew
Screen Dialogue by James Gleason

with
ROBERT ARMSTRONG
BARBARA KENT
BERYL MERCER

A WARNER BROS. PRODUCTION.

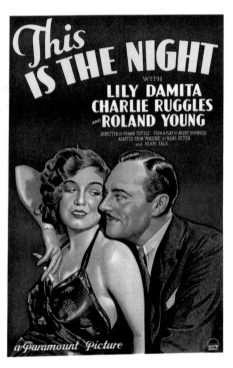

This Is the Night
U.S. (1932)
Studio: Paramount
Style "A"

The Half-Breed
U.S. (1922)
Studio: Morosco
Pictures/First National

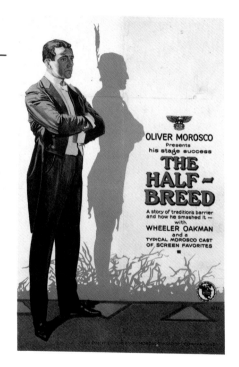

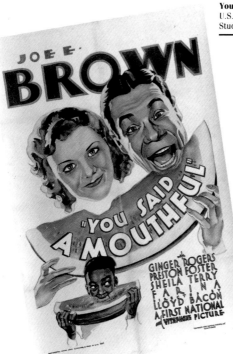

You Said a Mouthful
U.S. (1932)
Studio: First National

Gigolettes of Paris
U.S. (1929)
Studio: Educational
Robert Bentley/Neptune
Blood Smyth Collection

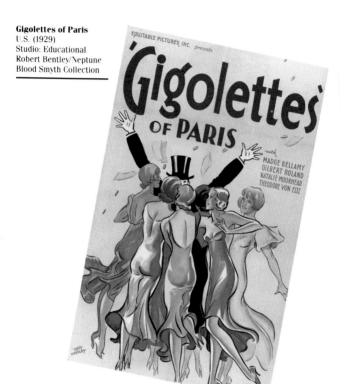

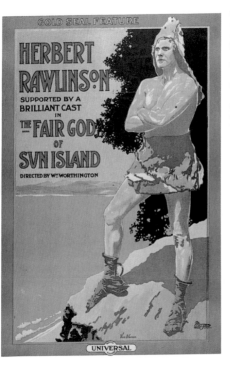

The Fair God of Sun Island
U.S. (1915)
Studio: Universal
Robert S. Birchard
Collection

Girl Without a Room
U.S. (1933)
Studio: Paramount
Style "A"

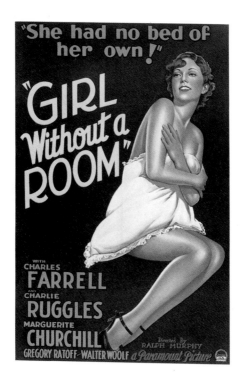

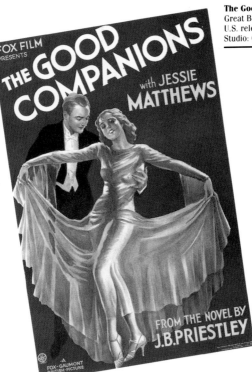

The Good Companions
Great Britain (1933)
U.S. release poster
Studio: Gaumont-British

Ladies They Talk About
U.S. (1933)
Studio: Warner Bros.
Lloyd Ibert Collection

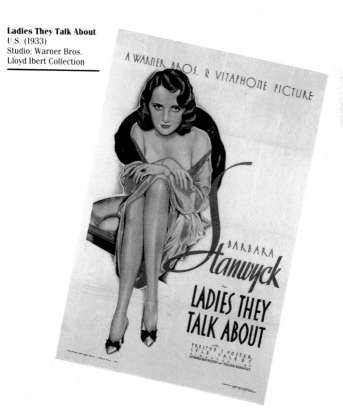

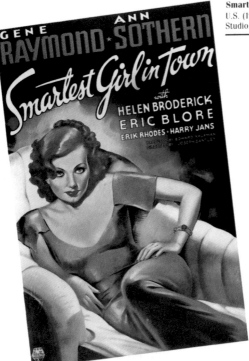

Smartest Girl in Town
U.S. (1936)
Studio: RKO

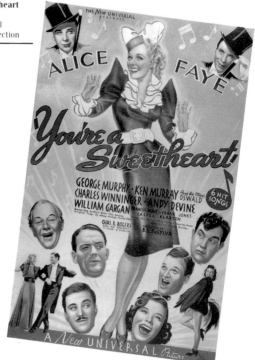

Hotel for Women
U.S. (1939)
Studio: 20th Century-Fox

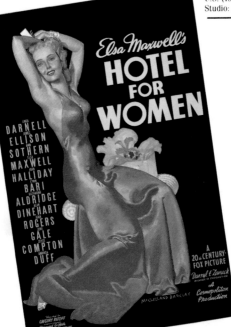

ACKNOWLEDGMENTS

Our special appreciation to our editor, Alan Axelrod, who saw everything that others did not, and to Julian Bach, an agent of exceptional integrity and enthusiasm. Our gratitude goes to John Cocchi for his intelligent and perceptive fact-checking and also to Robert S. Birchard, Martin Kearns, Richard Koszarski, Ira Resnick, Gary A. Smith, George Theofiles, and James Morgan Watters for their enthusiastic, perceptive, and eagle-eyed reading of the tome. Many illustrators, their families, art directors, archivists, industry executives, collectors, and dealers shared our obsession by graciously sharing their time, expertise and memories. Among them, thanks to Harold Adler, Miou-Miou and Jasmine Allpoints, Jack Banning, John Bresnik, Reynold, Franz and Mary Louise Brown, Robert K. Brown, Dan Content, Ruth Corbett, and Git, Phil and Din Luboviski of Larry Edmunds Bookshop, Tony Goodstone, Margaret Hadley, Al Hirschfeld, Albert Kallis, Jack Kerness, Bill Luton, José Ma. Carpio and Channing Lyle Thomson of Cinemonde, Kirby McDaniel, Walt Reed, Walter Reimer, Jack Rennert, Burton Robbins, Russell Roberts, Matthew E. Schapiro, Charles Schlaifer, Dorothy Schmidt, Richard Seguso, David Smith, Joseph Smith, Albert Tepper, and Robert Totten. Assistance from

Sam Gill, Howard Prouty, Linda Mehr at the Academy of Motion Picture Arts and Sciences' Margaret Herrick Library was most fortuitous. In New York, both the Library at Lincoln Center and the Society of Illustrators (whose curator, Frederick Taraba, rates a special bow) proved to be rich resources. Thank you, too, to Elena Millie at the Library of Congress. We wish to salute several preservationists for their expertise in restoring the posters as near to their original perfection as possible: Anita Noennig, Kathy Churchill, and Susannah Hays at Daedalus in Oakland, California, and Larry Toth, Paul Bos, Clay St. John, and Kliff Klair at J. Fields Gallery in New York. We appreciate the photographic skills and enthusiasm for the project shown by Louis Minaya, in Los Angeles, and George Roos, in New York. Blessings too, to the many who recognized movie posters were the stuff of dreams when Hollywood considered them the stuff of paper drives and landfill: Robert Bentley, Robert S. Birchard, Roy Bishop, Jean-Louis Capitaine, Bob Cosenza, Louis F. D'Elia, Frank M. Di Andrea, Todd Feiertag, Michael E. Hartmann, Lloyd Ibert, Sam Irvin, Harold Jacobs, Michael Kaplan, Martin Kearns, Richard Koszarski, John Malanga, John Martin, Louis Minaya, John Phillips, Ira Resnick, Philip Shimkin, Gary A. Smith, Neptune Blood Smyth, Daniel Strebin, George Theofiles, Peter Thompson, and James Morgan Watters.

All posters in this book are from The Carson Collection or The Allpoints Collection unless otherwise noted.